THE FICTION & SERIES brings into English for the first time influential works and writers from around the world, published under the joint imprint of Council Oak Books and Hecate. Editor of the series is French author Daniel Odier, best known in the United States for his novels *Diva* (written under the psuedonym Delacorta) and *Cannibal Kiss.*

Other titles in the Fiction & series are:

PUERTO RICO

Ballad of Another Time
José Luis González
Translated by Asa Zatz
ISBN #0-933031-10-6
$7.95

CUBA

Concierto Barroco
Alejo Carpentier
Translated by Asa Zatz
ISBN #0-933031-12-2
$7.95

For more information, call or write Council Oak Books, 1428 South St. Louis, Tulsa, Oklahoma 74120. 1-800-247-8850.

THE WRITER IN THE CATAS-TROPHE OF OUR TIME

ERNESTO SÁBATO

Translated by Asa Zatz

Series edited by Daniel Odier

COUNCIL OAK BOOKS/HECATE

with The University of Tulsa

Portions originally published as *L'écrivain et la catastrophe*
© 1986 Editions du Seuil

Council Oak Books
Tulsa, Oklahoma 74120

Library of Congress Catalog Card Number 90-080356
ISBN Number 0-933031-24-6

Designed by Carol Haralson

CONTENTS

ON ABSTRACT ART

THE NOVEL, RECOVERY OF PRIMORDIAL UNITY

APPENDIX: THE UNKNOWN LEONARDO DA VINCI

APOLOGIA

IT IS QUITE likely that my turbulent existence coupled with my quasi-barbarian status lends these notes a certain value. I am a marginal person in every sense, including the philosophical, since my scanty store of knowledge derives not from a philosophy department but from my three intense adventures in life: communism, the physiomathematical sciences, and literature.

As I was finishing secondary school, the rejection of the bourgeois world felt by so many adolescents turned me towards anarchism and subsequently the Communist movement which I left after several years, horrified by the crimes of Stalinism. A grand illusion was coming to an end and I could feel the ground slipping away from under my feet. I then plunged into mathematics, that mountain-aery refuge scarcely reached by the sound and the fury. I studied feverishly, giving myself shots of diaphanous opium, as I lived the artificial paradise of ideal objects. Majestic,

weightless cathedrals like the theory of relativity held me in thrall for a long time, until I could no longer hear the whispers and shouts that managed to filter through from the land of man; sounds that recalled my earthly condition, early anxieties, fleshly upheavals revealing to me that that perfect orb was not my true abode. Those feelings became overpowering while I was working at the Laboratoire Curie, particularly when we got the news of the most direful event of our time: the splitting of the atom by the hand of man. That microcosmic cataclysm seemed to me to herald the terrifying finale of a civilization that had developed precisely upon the basis of a science that was so very beautiful and, apparently, so far-removed from terrestrial vicissitude.

And so, I felt another illusion fading for me. I began to hanker for the world of art that I was so fascinated by as a child and which appeared to me at the moment to be the true rebellion against an alienated world. Why, then, be surprised that I should have sought out the surrealists if they represented the direct opposite of the scientific and bourgeois mentality? Thus, while working by day like an automaton on Rue Pierre Curie, I spent my nights in delirium. I felt intensely, profoundly, even with holy trembling, that my sojourn in science was also over. Surrealism seemed to me a purifying fire against a dehumanized culture. It would follow, then, that I should have given so much importance in these fragments to mythopoetic

thought and to man branded primitive by the Europeans, in their positivistic arrogance. History does not regress but in spirit all proceeds towards its opposite; and excessive scientism prompts us to reject it. And so, we shall weather this tragic crisis by recapturing precious attributes of that man who still retained the primordial unity of conscious and unconscious. As Schopenhauer so brilliantly put it, there are times when progress is reactionary and reaction progressive. And this is one of them.

I don't believe I am far off the mark in considering this book a sort of spiritual autobiography, the diary of a crisis at once individual and universal since it is a portrayal of the collapse of our time within a particular person. Irregular fragments of one who found himself obliged to reflect upon his own uncertainties, his hopes and despairs, as collected in *Hombres y Engranajes* (1953) and *El escritor y sus fantasmas* (1963).

Now that I begin to look back on my life I note that I have no more than mulled over some few obsessions which on certain occasions are manifested as rational endeavors and, on others, as ambiguous, vague, and contradictory phantasies. There is no doubt that if any bit of my life's work is to endure it will be one of those unexplainable deliriums. Because — as Holderlin said — any man is a god when he dreams but just a poor devil when he thinks.

E.S.

Buenos Aires, May, 1983

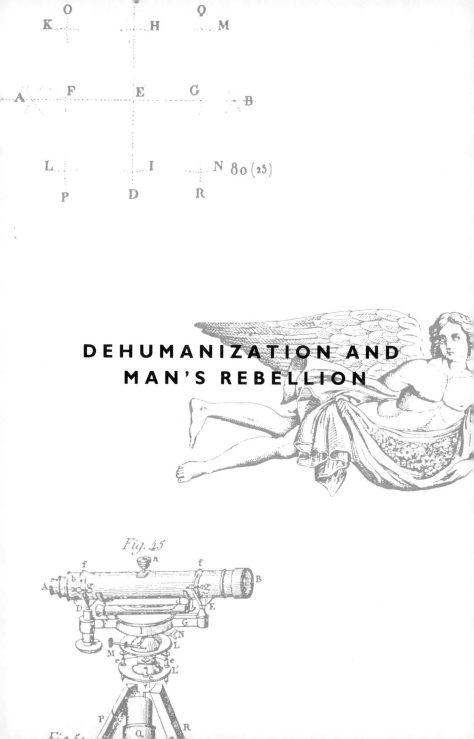

DEHUMANIZATION AND
MAN'S REBELLION

Fig. 45

THE WORLD GROANS and begins crumbling into blood-ied rubble to the astonishment of a humankind unaware of the sort of monster it had brought into being, brought proudly into being. The science that was going to solve not only the physical problems but the metaphysical ones began to herald its apocalypse with the baneful mushrooms over Hiroshima and Nagasaki.

Never in any other culture has a similar phenomenon occurred. It was necessary for a conjunction to have tran-spired of Greek rationalism, positivist science with its technology, and formidable economic concentration: three forces that launched upon the conquest of the material world. And they achieved it, but at the very high price of progressive dehumanization of the human being.

This is not the crisis of the capitalist system but that of an entire world concept which ended by casting the two final contestants, mass capitalism and mass socialism, in the same mold. The more powerful science became in

9

either of them, the further it distanced itself in the direction of an abstract Olympus, leaving the mankind it had engendered alone and unprotected. Triangles and steel, logarithms and atomic energy, joined together in the most alienating forms of the economy and state power to finally constitute a great mechanism of which men finally became the obscure and impotent cogwheels.

How could it have come to such a tragic crossroads? Man's first attitude toward nature was one of innocent love, of the kind professed by Saint Francis. However, as Max Scheler asserts, to love and to dominate are complementary attitudes and that selfless and pantheistic love was followed by a will to dominate that came to characterize modern man. Out of this will positive science was born, now no longer mere contemplative knowledge, but an instrument for dominating the universe. An attitude that ended in theological hegemony, liberated philosophy, and challenged science with the holy book. Secularized man — *animal instrumentificum* — was finally to launch the machine against nature in order to conquer and enslave it.

Land was the basis of the feudal world and, as a consequence, that world was static, conservative, and spatial. In contrast, the city was the basis of the new world and, as a consequence, society was to be dynamic, liberal,

and temporal. In this new order, time prevailed over space because it was dominated by money and reason, mobile factors *par excellence.* The new society is characterized by quantity. The feudal world was qualitative; time was not measured but lived in eternal terms, and it was the natural time of shepherds, of waking and labor, of hunger and eating, of love and the birth of children: the pulse of eternity. Nor was space measured, and the dimensions of religious images corresponded neither to distance nor perspective; they were an expression of hierarchy.

But when the utilitarian mentality came to the fore, everything was quantified. In a society in which the simple passage of time multiplied ducats, in which "time is money," it was logical that it be measured, and measured with utmost care. Starting in the fifteenth century, mechanical clocks invaded Europe and time was transformed into an abstract and objective entity that was numerically divisible. Not until the advent of the present-day novel was existential and intuitive time to be recovered by man.

Space was also quantified. A company contracting a ship to be loaded with valuable goods could place no trust in those drawings of an ecumene peopled by griffons and sirens; it needed cartographers, not poets. The artilleryman preparing to attack a stronghold needed a mathematician to plot the angle of fire. The engineer who built canals

and dikes, spinning and weaving machines, pumps for mines, the shipbuilder, the money changer, the military engineer, all needed mathematics and gridlined space.

The artist of that time arose from the artisan — actually, the same person — and it is natural that he should have carried over his technical concerns into art. Piero della Francesca, creator of descriptive geometry, introduced perspective into painting. Excited by this novelty, painters began using perspective broadly and with great ostentation, like some nouveau riches of this geometric art. Old Ucello was so entranced with the invention that his wife had to summon him repeatedly for his meals. Leonardo wrote in his Treatise: "Arrange at once the human figures, clothed or nude, in the manner that you intend, putting sizes and dimensions into perspective, so that no detail of your work appears to go against reason and natural effect." And in another fragment, he adds: "Perspective, consequently, must come first in all of man's discourse and disciplines. In its domain, the luminous line combines with the varieties of demonstration and gloriously bedecks itself with the flowers of mathematics and, even more so, with those of physics."

And so, proportion also came upon the scene. Trade between the Italian city-states and the Orient paved the way for the resurgence of the Pythagorean ideas that had

ruled Roman architecture. However, it was not until the emigration of the scholarly Greeks of Constantinople that the true *risorgimiento* of Plato began in Italy and through him of Pythagoras. Cosimo takes the scholars under his wing and himself follows their teachings at the Academy of Florence. In this way, Pythagoras's numerological mysticism married with that of Florence, inasmuch as arithmetic rules equally the worlds of polyhedrons and of business. The old tyrant set aside his serious concerns and, entranced, attended discussions at the Academy; and by a complex mechanism, Socrates assuaged him in his latest poisoning.

Nothing portrayed the spirit of the time better than the work of Luca Pacioli, a kind of department store wherein all manner of things might be found, from the inevitable glorification of the Duke to the proportions of the human body, from double-entry bookkeeping to the metaphysical transcendency of the Divine Proportion: "This proportion of ours, oh sublime Duke, is as worthy of prerogative and distinction as anything there is, with due regard for your boundless power, since without your knowledge very many things quite worthy of admiration could not have come to the fore either in philosophy or any other science." He characterized it as divine, exquisite, ineffable, extraordinary, essential, admirable, inestimable,

sublime, supreme, and ineluctable. It is as though he were speaking of the Duke of Milan himself.

But this is schematic, and history is never linear. The Renaissance, like any other epoch, can be accurately judged only if looked upon as struggle and synthesis of opposing impulses. The assertion — provisional and partial — that the Renaissance was a process of secularization does not imply negation of Savonarola's or Michelangelo's mysticism. Suffice it to feel for a moment the tender, tremulous expression of Donatello's Saint John to understand how inconsequential it is to consider the epoch a merely profane one. A doctrine cannot portray a society univocally but only in complex and equivocal form; partly through the independent and purely intellectual development of the foregoing ideas (for or against those ideas), partly as a manifestation of the spirit of the time; and this also polemically: the religious spirit of the Middle Ages is effectively superseded by the profane spirit of the bourgeoisie, but its most outrageous manifestations called forth Savonarola's mystical reaction. Such artists as Michelangelo and Botticelli were strongly moved by that reaction and not only did not contradict the effort at profanation but were its inevitable consequence.

It is therefore incorrect to assert that the Renaissance is a turning back to antiquity. History never turns back.

Rather, it was a return of certain characteristics of the Graeco-Latin spirit to the degree in which it had also been a civic spirit, the product of a culture of cities, a *civilization*. But Renaissance cities were different from those of antiquity solely because of the existence of Christianity. How can the realism of a Christian like Donatello be compared with the realism of a Greek sculptor of the enlightened epoch?

However, there were other factors besides Christianity that complicated the problem. As Jung said, the cultural process consists of a progressive domination of the animal in man, a process of domestication that cannot be realized without resistance on the part of the animal nature desirous of freedom. From time to time, a kind of inebriation attacks humanity, entering through the pathways of culture. Antiquity experienced such intoxication in the wild Dionysian orgies of the Orient, an essential element of classical culture. According to Heraclitus's "enantidrome," everything proceeds towards its opposite in the world of the spirit and the Dionysian orgy had to follow the Stoic ideal and then the asceticism of Mitra and Christ; until, with the Renaissance, a new and exuberant enthusiasm sought to take possession of man. This spirit explains the "two-facedness" of many great men which in certain cases culminates in neurosis. One finds a struggle everywhere between magic and science, between the desire to violate

natural order — how sexual the very expression is! — and the conviction that power can only be attained through respect for order. In an aphorism, Leonardo asserted that "nature never breaks its laws" but in one of his demiurgical outbursts, he arrogantly exclaimed: "I want to work miracles!" The Renaissance is replete with witchcraft; the work of alchemists and astrologers is eminently Renaissance, and no little of the chemistry and astronomy of our time has its roots in those extravagant attempts. And it should not come as a surprise that Roger Bacon, one of the fathers of modern science, should have been thought to be a powerful magician.

This duality explains the neurotic dissatisfaction that came out in the work of so many artists. Western man could no longer go back to nature in the state of mind of certain Greeks because Christianity now existed. The yearning for classical perfection, now never again attainable, was felt among the people of the *quattrocento*, the disassociation established by the Christian conscience between divine and earthly life, the eternal and the transitory, now seemed insurmountable. This disassociation was more intense in the Germanic countries than in Italy because it was an ancient land, and it is not surprising that even the popes themselves should have succumbed to the profane outlook. The Gothic incursion was the other force of

modernity, a force which, now hidden, now visible, made the basic conflict of our civilization more dramatic, finally flowing into the Protestant and later the romantic and existential rebellions. Berdiaeff sees in Gothic architecture stretching agonizingly upwards, incapable of Graeco-Latin moderation, the materialization of this conflict of the European soul, of that quality of the impossible that seems to be the hallmark of a truly Christian culture.

To sum up, if what we understand by Renaissance is not the mere concept of the humanists but the beginning of Modern Times, it must be considered the awakening of profane man in a world essentially moved by the Christian and the Gothic; as a civilization that simultaneously produced palaces in the old style and Gothic cathedrals, petit bourgeois anti-clericals like Valla and religious spirits like Donatello, realistic and satirical literature like Boccaccio's and a vast Christian drama like *The Divine Comedy*. Let us discard the ancient formulas of the humanists for whom the Renaissance was nothing more than a return to antiquity; and let us disregard their theories on the aberration of Gothic art. The complexity of that period and the dramatic dualism of our day can be appreciated only if we admit that this time of ours was born out of the interaction of peoples of varying races and traditions. Italy never completely lost its feeling of being an ancient people, nor did

it ever forget the Graeco-Latin splendor that survives in the ruins of its theaters, aqueducts, and statuary. In the Nordic cities, however, built up around feudal fortresses, the rise of our civilization was to be accomplished with more barbarous and modern attributes; cities that came to be the seat *par excellence* of capitalism but, at the same time, cradle of the most violent reactions against our civilization: romanticism and existentialism.

In the nineteenth century, the dogma of generalized and unlimited Progress (with a capital letter) took root. A fabulous outlook lay in store for man of the future, and Great Inventions would not only guarantee more light being shed per square meter but also the dispelling of the mythological murk. A turn of mind, this, that took positivism as its philosophy, not only in its highest forms but also in its most elementary scientism and materialism. The reign of science was absolute and undisputed because epistemological doubts that were to shake the faith of believers in the twentieth century had not even appeared upon the horizon. The mysterious invisible radiations discovered and harnessed by man showed that "soon" all the physical and metaphysical mysteries would be disclosed and put at humanity's service, placing those of man's soul and of wireless telegraphy in one and the same ontological pigeon hole. Myth was relegated to the Museum of Su-

perstitions and the identification of demystification with demythification that characterizes progressives to this very day was ushered in. Professor Haeckel, a forceful zoologist, launched his materialist monism which was nothing more than Ionic hilozoism, over two thousand years behind time. And the *Deutsche Monistenbund* (German Monist Circle) took it upon themselves to bring the good news to neighborhood libraries together with the works of Darwin, the man who was giving cosmic certification to the doctrine of progress.

However, to repeat, history develops through contradictions, and so this sinister attempt could not be realized in the pure form that the prophets of man's reification would have liked. Man is refractory and that is his essential difference from the thing.

Exact dates for the romantic rebellion cannot be established if we grant the movement its profoundest significance: redemption of life values as against strictly intellectual ones. It was a movement that never ceased to exist from the very moment in which Platonists decreed the excommunication of the body and its passions. Sometimes openly, sometimes secretly, that indomitable resistance never disappeared until it burst through in full force towards the end of the eighteenth century to attack the ideas so laboriously put forward by progressivism. From

the Renaissance to the French Revolution it rose up not only in art — where it was an essential condition — but in thought itself, with Pascal in France, Swift in England, Vico in Italy, and Swedenborg in Sweden. The irresistible power of the unconscious was revealed, of course, in exemplary fashion in fictional literature and the specters of black despair may be glimpsed through the cortex of enlightened thought even in the *Candide* of one of the champions of modern times; to say nothing of *Rameau's Nephew* by the editor himself of the *Encyclopedia.*

The case of Germany is curiously significant where there had been a people so much more predisposed to romanticism than any other that it even provided the philosophical foundation for the movement. By virtue of that paradox which is common in the unfolding of the spirit, it was to encounter its own romanticism through importation from the most intellectually prestigious country — a phenomenon that was also to occur on a vast scale throughout the Latin American hemisphere, romantic to the marrow. The German people lived under the yoke of French ideas from Frederick the Great's time to the point where its *Aufklaerung* was an imitation of Illuminism. And it is one of the ironies of dialectics that the rediscovery by those peoples of their own romantic nature should have been made through its gallicization. The *Sturm und Drang*

was largely an outgrowth of Rousseau's ideas and that movement, with its *Kraftmensch,* demiurge, and force of nature, was to lead not only to German romanticism but to Nietzsche's philosophy itself. The disenchantment of culture as an effect of rationalism provoked in this way the renascence of the magical and this peculiarity was then to be seen in Hamann, for whom poetry was a form of prophecy. From him to his disciple, Herder, and from Herder to young Goethe, the Eleusinian mysteries were the key to the new poetry. It cannot come as a surprise that they should have redeemed dream, infancy, the primitive mind. Herder saw in poetry the manifestation of the elemental forces of the soul and in poetic language man's primordial language; that of metaphor and inspiration, not the rigid and abstract tongue of science. It was as though he had read Vico. The discovery of Shakespeare by these Germans is symbolic of the insurrection. And that his romanticism was probably the most precious quality old Goethe still covertly preserved was manifest in his defense of Byron and the assertion that "to be a poet one must deliver himself up to the devil." Through dream and madness, inebriation and ecstasy, the German romantic thus saw in poetry and music the road to true knowledge, reviving in a certain way thereby the initiation doctrines of antiquity and challenging the roots of the Socratic spirit

and bourgeois thought.

Romanticism was not a mere movement in art, to be sure, but a most profound rebellion of the spirit that could not refrain from attacking rationalist philosophy at its very foundations. Things had gone too far for them not to begin turning back. In opposition to the adolescent enthusiasm of the technicians the suspicion arose that this mentality could be disastrous for the fate of the human animal. In the face of the frigid museum of algebraic symbols, flesh and blood man was asking himself of what use that vast apparatus of universal dominion was if it could not lessen his angst before the dilemmas of life and death. In the face of the problem of the essence of things, the problem of man's existence was posed; and in the face of objective knowledge, man's knowledge was championed, tragic knowledge because of its very nature, divorced from reason.

Nietzsche asked himself if life should dominate science or vice versa, and in answer to this characteristic question of his time, he asserted the primacy of life. To him, as to Kierkegaard, as to Dostoevsky, existence could not be ruled by the head's abstract reasoning. Life is contradictory and paradoxical. Kierkegaard planted his bombs at the foundations of the Hegelian cathedral, culmination and glory of rationality. However, on attacking

Hegel, he was actually attacking all of rationalism, ignoring its facets and variants with the holy high-handedness of revolutionaries, until finally attaining simply reasonable behavior. There was yet to be time, as was the case, to compensate for the damage. The radical incomprehensibility of the human being is a defense against the system. The existent is irreducible to the laws of reason, it is the Dostoevskian madman who shocks with his tenebrous truths, that man possessed by the devil — and who is not? — who convinces us that for man disorder is often preferable to order, war to peace, sin to virtue, destruction to construction. This strange animal is contradictory, cannot be studied like a triangle or with chains of syllogisms. He is subjective and his feelings are unique and personal. He is a contingent, an absurd fact that cannot be explained. There is no answer in the System to his questions because that System is based on universal essences and man is a concrete existence.

Actually, however, the elements for his negation were already present in Hegel himself since to him man was not that entelechy of the Illuminati but an historical being who makes himself, attaining the universal through the individual. This transformation of man not solely into an historical process but into a social phenomenon provided an historical sense that was to be a genuine reaction against the

extreme rationalism of his disciple Marx. He says it: "Man is not an abstract being lurking outside the world, man is the world of men, the state, society." And his conscience is a social conscience because if man of *ratio* were an abstraction, solitary man would also be. Transformed into an entelechy by rationalists like Voltaire, alienated by a social structure that has converted him into a mere producer of material goods, Marx set forth the principles of a new humanism: Man can win his condition of total being by rising up against the mercantile society that utilizes him.

It is superfluous to point out similarities between this doctrine and the new existentialism which after Husserl managed to surpass Kierkegaard's extreme subjectivism; his interest in concrete man, his rebellion against reason, his idea of alienation, his vindication of *praxis* over *ratio*. But we should, indeed, indicate that the new existentialism goes much further than Marxism in this redemption, since there is a dangerous remnant of enlightened thought in Marxist doctrine. There was a duality in Marx. On the one hand, his romanticism caused him to revere Shakespeare and the great British and German poets, as well as to feel nostalgia for the chivalric values expunged by a crude society of merchants. On the other hand, he had a powerful rationalistic mentality and so admired science that he described his socialism as "scientific." His *praxis*

signified the superiority of experience and action over pure reason, and in this he departed from rationalism. Furthermore, however, he shares with the Illuminati the myth of Science and Light versus the dark powers. However, since these powers were of decisive importance to concrete man, in repudiating that world of magical thought resistant to logic and even to dialectic, he repudiated in good measure the very concrete man he was at the same time trying to rescue. And that was not all. Because, although it is true that pure reason leads to a kind of entelechy in place of man, it is also true that experimental science, compounded of reason plus experience, leads to an abstract scheme of total reality and to the inevitable alienation of man in favor of the objective world. An alienation that did not occur to Marx.

The great philosophies of existence, then, are the ones that rigorously represent man's rebellion in this crisis of the Western world.

ART AS KNOWLEDGE

SCIENCE AND ABSTRACTION

FOR CENTURIES the man in the street had more faith in witchcraft than in science. Kepler was obliged to earn his living as an astrologer. Today, astrologers advertise in the newspapers alleging their procedures to be strictly scientific. The man in the street fervently believes in science and worships Einstein and Mme. Curie. However, as gloomy destiny has decreed at this moment of popular glory, many of the professionals have begun to doubt its power. Whitehead has told us that science should learn from poetry. In singing the beauties of heaven and earth the poet sets forth not phantasies of his naive conception of the world but rather concrete facts of experience "adulterated by scientific analysis."

This divergence of professional and layman is probably due to the fact that the development of science involves, at the same time, growing power and increasing abstraction. The man in the street, always disposed to take the victor to his bosom, sees only the former; the theore-

tician sees both aspects, but the latter begins to worry him in a fundamental sense to the point of making him dubious of science's aptitude for apprehending reality. This two-sided outcome of the scientific process seems contradictory in itself. Strictly speaking, it is the double face of a single truth: *Science is powerful not despite its abstraction but precisely because of it.*

It is difficult to separate everyday knowledge from scientific knowledge. However, it may perhaps be said that the first refers to the particular and concrete and the latter to the general and abstract. "The hot stove" is a concrete proposition, homely and affective, even, reminiscent of Dickens. The scientist takes from it something that has no relation to these associations. Armed with certain instruments, he will observe that the stove's temperature is higher than that of the environment and that its heat passes to the surroundings. In the same manner, he will examine other like assertions, such as "the iron is red hot" or "those who come late will drink cold tea." The result of these observations and measurements will be a single, flat conclusion: "Heat passes from a hot to a cold body."

This is still quite within the grasp of the ordinary mind: The *desideratum* of the man of science is to put forth judgements so general that they are unintelligible, an end achieved with the aid of mathematics. He is not yet

satisfied by the foregoing statement and will be content only when able to say: "The entropy of an isolated system increases constantly."

Likewise, questions such as the dropping of Newton's apple, the existence of Niagara Falls, the formula for accelerated motion, and Cyrano's accident may be successfully brought together in the proposition: "The tensor g is nil," which as Eddington observed, has the virtue of conciseness but not yet of clarity.

The "hot stove" proposition expresses certain knowledge and for that reason confers certain power on the one who possesses it. He knows that if he is cold it would be a good idea to move close to a stove. But this knowledge is quite modest and will be of no use to him in any other situation.

However, if somebody has full awareness that "the entropy of an isolated system increases constantly," not only will he look for a stove at which to warm himself — a very meager return after twenty years of study — but he will be able to solve an enormous number of problems ranging from the operation of a motor to the evolution of the universe.

Thus, to the degree in which science becomes more abstract and, consequently, further removed from the problems, concerns, and language of everyday life, its

usefulness increases in the same proportion. A theory has more applications the more universal and, hence, the more abstract it is, since concreteness is lost in particularity.

Science garners power thanks to a kind of pact with the devil: at the cost of mounting evanescence of the everyday world. It succeeds in becoming king but, on achieving that status, its kingdom is only a ghost realm.

It becomes possible to unify all those propositions because concrete attributes are eliminated that make it possible to distinguish a cup of tea, a stove, and latecomers. That process, a winnowing process, leaves little. The infinite variety of concretions that make up the universe around us disappears. First, there remains the concept of *body* which is quite abstract, and if we go on, the concept of *matter* is barely left to us which is even vaguer; the rack or dummy for any dress.

The universe around us is one of colors, sounds, and odors all of which disappear in the scientist's instruments like an immense phantasmagoria.

The Poet tells us:

> *The wind winnows the fruit trees*
> *Offering a thousand fragrances to be sensed;*
> *The boughs sway with a gentle noise*
> *Causing gold and scepter to be forgot.*

But scientific analysis is depressing. Like inmates entering a prison, sensations are converted to numbers. The green of those trees swayed by the breeze occupies a zone on the spectrum of about 5,000 angstrom units; the gentle sound is picked up by microphones and split into a group of waves each identified by a number; as for the forgetting of gold and scepter, that remains outside the scientist's jurisdiction since it cannot be mathematically converted. The world of science ignores values. A geometrician who rejects a theorem because he considers it perverse would have more chance of being locked up in an insane asylum than of being heard at a mathematics congress. Nor would there be any sense to an assertion like this: "I have faith in the principle of the conservation of energy." Many scientists make affirmations of this nature but that is due to their construing science not as scientists but simply as men. Giordano Bruno was burned at the stake for having uttered such statements as, "I believe passionately in the infinity of the universe." It is understandable that he should have undergone torture for this sentence as a poet or metaphysician; but it would be lamentable had he believed he was suffering the torture as a man of science because, in that case, he would have died for an inappropriate observation.

Strictly speaking, value judgements have no place in

science, although they do enter into its structuring. The scientist is a man like any other and it is natural that he should work with the entire baggage of prejudices and esthetic, mystical, and moral tendencies that make up human nature. But one must not be guilty of the fallacy of adjudicating these vices of the *modus operandi* to the essence of scientific knowledge.

And so, in this way, the world has been gradually transformed from a complex of stones, birds, trees, Petrarchan sonnets, fox hunts, and electoral contests, into a conglomerate of sinusoids, logarithms, Greek letters, triangles, and probability curves. And what is worse, *nothing other than that.* Any scientist would refuse to speculate on what there might be beyond mere mathematical structure.

Relativity completed the transformation of the physical universe into a mathematical phantom. Previously, bodies were at least persistent chunks of matter that moved in space. The unification of space and time has converted the universe into a complex of "events" and, in the opinion of some, matter is a mere expression of the cosmic curvature. Other relativists imagine that there is no past, present, or future in the universe. As in the realm of Platonic ideas, time would be another of man's illusions, and the things he believes he loves and the lives he thinks

he sees transpiring would be no more than imprecise phantoms of an Eternal and Immutable Universe.

Strict science — that is, mathematicizable science — is removed from everything the human being sets most value on: his emotions, his feelings about art or justice, his anguish over death. If the mathematicizable world were the only true world, not only would a dream palace with its ladies-in-waiting, minstrels, and equerries be illusory, but so would early-morning landscapes or the beauty of a Bach fugue. Or, at least, what moved us in them would be illusory.

FUTURE OF IGNORANCE

BERTRAND RUSSELL OBSERVED that popularized explanations of relativity cease being intelligible precisely at the point they begin to say something important. Excellent symptom of what is happening with present-day knowledge, and a presage of future catastrophe.

The universe is diverse but it is also one. Beneath the infinite diversity there must be a unitary warp which has to be discovered through efforts at synthesis. But with each passing day it is becoming more difficult to make the syntheses because of the growing abstraction, complexity, and mass of diverse facts that must be covered. And when someone capable of a universalizing effort arises, he is partially understood and mistakenly judged.

Furthermore, a Whitehead is not universal in the sense that Leonardo — perhaps the most complete of this fauna on the way to extinction — was. This type of man is interested in the total universe: the concrete and the abstract, the intuitive and conceptual, art and science. But

the development of these different phases of human activity has been imposing specialization.

Who today is himself capable of painting like Velazquez, constructing a scientific theory like Einstein, and composing a symphony like Beethoven? The study of physics alone requires a lifetime. When learn to paint like Velazquez, even assuming possession of his natural attributes, and how learn all that chemistry, biology, history, philosophy, and philology have, in turn, accomplished? And, above all, who could be capable of achieving a synthesis of this almost infinite world?

For universal spirits the only recourse is melancholia. Valéry, to some degree, is representative of this situation in which reality would be supplanted by a conjoint of yearnings and unsatisfied desires for universality. In *Passage de Verlaine* he relates how he would observe the poet passing by almost daily. Flanked by his friends, he would astonish the neighborhood with his brutal majesty and barbarous tongue, stopping from time to time to give vent to invective. A few minutes earlier, a different species had passed by, stooped, grave, silent, fixed and absent gaze, moving clumsily in one of the many mathematically possible universes. Henri Poincaré. Says Valéry: "I had to choose, in order to think, between two orders of admirable things mutually exclusive, so similar in the purity and

profundity of their aims."

What would Paul Valéry not have given, then, to be something like the sum of Verlaine and Poincaré? But Athens was already very distant and so was the Renaissance. All that remained was to dream like Leonardo and yearn for *l'uomo universale.*

The future will be in the hands of specialists which, I believe, calls neither for pride nor rejoicing. There are many people who become suspicious when a man like Whitehead discusses politics or morality. They feel that a thorough ignorance of logic, science, and philosophy is a good recommendation for statesmen and sociologists.

Modern science — technology, particularly — owes so much to the specialist that the man in the street, always amenable to fetich worship, has created the fetichism of specialization, confusing a lamentable consequence of the progress of science for its main motor.

This is not to negate the value of specialization. The sciences have reached a degree of development such that one is condemned to specialize if he wants to reach the front where the struggle against the unknown is being waged. It is also certain that the vast contribution of *facts by specialists has been, and is, continually a factor in progress (suffice it to recall the discovery of radioactivity, the photoelectric effect, and so many others). But it must be pointed*

out that the great advances of scientific thought are not established through isolated facts but through theories, through conceptual syntheses, and it is inconceivable that specialists should be capable of making syntheses that go beyond their fields. Mme. Curie, who patiently isolated a new chemical element, is a specialist; Einstein, who brought together thousands of small facts provided by specialists into a great theory, is a man of synthesis. That is the gap between an ordinary investigator and a genius.

A man is capable of carrying out synthesis only to the degree in which he is capable of rising above his own territory to determine from a bird's-eye view his place with respect to neighboring territories. But, as time goes by, life in each of them becomes more complex, richer, and the language, which was a dialect of the mother tongue, separates, is converted into something autonomous and partially incomprehensible to a neighbor. It is becoming more and more difficult to find bonds, the maternal tracks. The dilemma is inevitable and it seems that we are to come up short at a frontier beyond which all progress will be impossible.

The development of physics is exemplary, being the simplest of the natural sciences and, therefore, the one that has gone farthest. As in all branches of scientific knowledge, its advance has been marked by successive

unifications. Newton showed that the fall of a body and the movement of a planet are phenomena governed by the same law. Oested and Faraday proved that electricity and magnetism are not independent but two expressions of a single reality. Mayer and Joule demonstrated that heat and work are basically connected. The physicists of today are trying to unify gravitational and electromagnetic phenomena.

But each unification has been more difficult than the preceding one and, to the degree in which they have been advanced, it has appeared that the rationalizable limit was being approached. At one point it seemed that the *quanta* were that limit; beyond, there stretched the vast and strange domain of the irrational. As in a darkened, unfamiliar house, physicists moved about blindly, unable to locate doors or stairs. The physics of an earlier time, clear and logical, fulfilled its basic mission — it explained and predicted. Now, facts are bizarre and frequently arrive without anybody expecting them. The theoreticians, then, invent complex hypotheses for justifying them. The specialty of current physics seems to be like prophecy in the past. How far away those good old days of Le Verrier are, when an astronomer, seated at his desk with pencil, paper, and calculating machine, could discover a planet! Now, a uranium atom explodes and the physicists, confused but

ever vain, try to assure the paternity of the explosion with many telegrams *post factum.*

Caught up in a tangle of equations, men of science are looked upon smugly by philosophers who, not having cared to take the trouble to understand them, prefer the role of spectators and, from time to time, to draw hasty conclusions on the basis of phrases they do not understand. This is what happened with the Heisenberg principle. It was thought to reveal the free will of matter. It was imagined that science supported irrational postulates. This phenomenon was linked to the rise of the subconscious, establishing some vague connection between Freud, Heisenberg, and André Breton. It was supposed in some way to explain war and the existence of evil among men.

At the root of this phenomenon is simply the fact that things are becoming very complicated. To establish the law of falling bodies is child's play in comparison to the conceptual complexities that a contemporary physicist must cope with: space-time, the ratio between mass and field, the unification of gravitational and electromagnetic fields, the rationalization of the quantum postulates, the conciliation of mechanical reversibility with the essential irreversibility of real processes.

Why assume that these dilemmas demarcate the limits of the rational and not the bounds of human capacity

overwhelmed by the weight of a formidable mass of knowl-
edge and facts necessary to fit into the Jigsaw Puzzle? It
may be assumed that there is a practical and not a theo-
retical inability to rationalize reality. Physics has developed
on such scale that specialization has become necessary in
every one of its sectors, with the drawback that those
specialists understand each other less and less. One who
measures spectra may be incapable of understanding an-
other concerned with nuclear theory.

If this happens between two atomic physicists, what
can we expect in the way of mutual understanding between
physicists, biologists, and sociologists? For philosophers,
this problem is vexing to the utmost. Certain optimists
assume that philosophy may do without science which to
me seems a curious way of working toward universality.
In the halcyon days, the philosopher was a kind of sum
total of the knowledge of the epoch. Aristotle was a phys-
icist, mathematician, biologist, and sociologist. In time, this
condition became a luxury. Descartes and Leibniz were
still universal spirits but after them the exodus of the
particular sciences began. Some think that after all that
was gone, philosophy was left so purified that *nothing*
remained. This seems an exaggeration; ontology, gnoseo-
logy, and logic remain. That is, *only* the universal would
remain. However, is it admissible to ask: Can a boundary

be established between the universal and the particular? Would it be possible for a philosopher ignorant of the particular sciences to establish general laws of being and knowing? The great thinkers of all periods based their investigations on the science of the time. But, since science has become unnavigable, most philosophers have decided to change the system and seem to believe that a solid ignorance of mathematics, logistics, and relativity is an advantage. Nevertheless, it is not clear how the philosophers of the future are going to be able to cope with the problem of space, time, and causality without the help of physics and mathematical group theory.

This should not be taken as an attack on philosophers. It is against the ingenuous notion that it is possible to address the universal by suppressing the particular. The inverse of this ingenuousness is that of the men of science who believe they can address the particular without consideration of the general. That is the ingenuousness of the specialists.

The triumph of the positive sciences in the nineteenth century and the inability of idealist philosophy to solve the problems of the physical world brought discredit upon philosophic speculation in the field of science. Chemists, physicists, biologists, and even psychologists boasted of ignoring and even detesting it. In that epoch it seemed

sufficient to investigate reality by weighing, taking temperature readings, measuring reaction time, observing cells under the microscope. A type of physicist came into being who had faith only in such things as tape measures or scales, and who scorned philosophy, a tendency that extended to include persons who were unrelated to science but admired its precision (Valéry). The god of the philosophers conceived a punishment for those who spoke ill of philosophy, including Valéry: that such chatter be *also* philosophy, but bad philosophy. The same thing happened to these physicists as to those peasants who, having no faith in banks, hide their savings under the mattress, a less secure place than a bank. If the structure upon which they base their observations is analyzed, it becomes evident that it was not true that they had no philosophical position; they had a very bad one. The lack of an epistemological criterion made them accept without due caution articles of dubious quality in the belief that a good instrument could not produce a miserable result. It suffices to consider the conviction of a physicist of this kind that he was not engaged in philosophical speculation when he measured time with a clock. Nonetheless, he was basing himself on a metaphysical hypothesis — absolute time — that invalidated his experimental results. He was unaware that a clock can be more dangerous than a treatise on

metaphysics.

Relativity and quanta ushered in a new era marked by an analysis of scientific knowledge. Theoretical physicists had to convert themselves into epistemologists in the same way that mathematicians ended up in logic.

The past century drew a dividing line between science and philosophy which sought to be definitive but only resulted in being disastrous. In *The Philosophy of Physical Science,* Eddington discusses the consequences of this attitude. Formally, it is still possible to recognize a division between science and epistemology; but it is no longer an effective division. Epistemology is the territory where science is superimposed on philosophy, which does not mean that physics must now be in the hands of philosophers who remained in philosophy. On the contrary, present-day physics must have a decisive impact upon the concept of the world, as happened with Copernicus and Newton. It seems logical to think that those syntheses should be made by philosophers but it so happens that, in general, philosophers are ignorant of physics and it is hardly reasonable to leave the study of the philosophical consequences of physics to people who do not understand it. Nor does it seem possible that such synthesis should be developed by specialists.

What it comes down to, then, is that these syntheses

must be produced by a kind of mathematician-logician-physicist-epistemologist-grammarian. And there is gloomy justification for doubting that such a superman will ever exist. He would, in fact, have to solve, in addition to the problems of physics, those of chemistry, biology, and history. He would have to enter the terrain of logic with all the modern baggage of logistics and mathematical group theory. He would have to link the absolute with the invariables of these groups, space-time and causality with the philosophical problems of progress, morality, and the absoluteness or relativity of esthetic values. The language of such monsters would also have to be monstrous; discussion would perhaps be couched not in terms of nouns, adjectives, transitive and intransitive verbs but of invariables, relatives, functions, immanent and transcendent verbs. This language would probably leave off being oral to become a world of abstract symbols in imposing array to be looked upon in amazement, terror, and admiration by the man in the street. *Reason* — motor of science and philosophy — *would have finally triggered faith,* since the man in the street, totally incapable of comprehending, would replace comprehension with fetichism and faith.

There is no motive, however, to hold out much hope in this regard (if such a language and situation could hold out hope for anybody). It is true that the discovery of new

conceptual apparatus could expand man's mental capacity in the way a lever augments his physical power, but experience has shown that the number and complexity of problems grow much more rapidly than man's capacity to understand. Men like Whitehead are still to be found on earth but events will rapidly overtake and pass the span of these universal men and, then, human thought happily embarked from some port on the Ionic coast will find itself lost in a dark, immense, and raging sea.

In the beginning was Chaos. With the birth of science and philosophy, man was putting the external in order and trying to verify the idea of its Author, should there be one. And so, there appeared the Cosmos, Order, Law.

But the thirst for knowledge unleashed a new kind of Chaos. We emerged from ignorance to arrive again at ignorance, but at a richer, more complex ignorance compounded of minute and infinite wisdoms. There was almost nothing of the world unknown to Aristotle. All the knowledge of his time was contained in that powerful brain; there were no vitamins, tensors, groups, conditioned reflexes, non-Euclidean geometry. But science continued advancing and each advance made by it or by philosophy signified a new ignorance to be incorporated into the spirit of the layman. We learn every day of a new theory, a new model of the universe that has taken its place in the vast

continent of our ignorance. And, so, we feel benightedness and bewilderment closing in on us from all sides and ignorance advancing towards a boundless and fearful future.

ART AS KNOWLEDGE

SINCE SOCRATES, knowledge has been attainable only through pure reason. At least, that was the ideal of all rationalisms up to the romantics, when passion and the emotions were accredited as sources of knowledge, at which point Kierkegaard arrived on the scene to assert that "the conclusions of passion are the only trustworthy ones."

The two extremes are, of course, an exaggeration, and the absurdity lies in applying to man a criterion valid for things and vice versa. It is quite evident that neither rage nor pettiness contribute anything to a theorem. Also reason is blind to values and it is not via reason nor through logical nor mathematical analysis that we evaluate a statue, a landscape or a love. The dispute between those who point to reason as having primacy and those who defend emotional awareness is simply a dispute over the physical universe and man. Rationalism (let us not forget that to *abstract* means to *separate*) sought to separate the various

"parts" of the soul, reason, emotion, and will; and once the brutal sundering had been wrought, it sought to establish that knowledge was obtainable solely through pure reason. Since reason is universal, since the square on the hypotenuse is equal to the sum of the squares on the two arms for everyone in any period, since what is valid for all seemed to be synonymous with The Truth, *the particular was the falsehood par excellence.* And so, the subjective was discredited; so, the emotional disparaged and concrete man guillotined (frequently in the public square and in fact) in the name of Objectivity, Universality, Truth and, what was more tragicomic, in that of Humanity.

Now, we know that these partisans of clear and definite ideas are basically mistaken and that if their norms are valid for a bit of silicate, it is as absurd to apply them to knowing man and his values as it is to claim familiarity with Paris through having read its telephone book and consulted its maps. Now, anybody knows that the most valuable sectors of reality (most valuable for man and his fate) cannot be apprehended through abstract schemes of logic and science. And if it is impossible to assure ourselves through intelligence alone of the existence of the outside world, as Bishop Berkeley demonstrated, what can we expect with regard to problems that refer to man and his passions? Unless we negate the reality of a love or a

madness, we must conclude that knowledge of vast territories of reality is reserved for art and art alone.

ART CRISIS OR CRISIS ART?

ARE THOSE THINKERS RIGHT who proclaim the decline of the novel form? Is the work of a Joyce or a Beckett not somehow a reductio ad absurdum of all fictional literature? Is the great crisis of our time also the general crisis of art, its total and basic dehumanization? Have we come to a dead end with no recourse but to transform our novels into chaotic instruments of disintegration?

All these questions have concerned me for many years, since for me, as for other writers of today, literature is not a pastime nor an evasion but a form — perhaps the most complete and profound — of examining the human condition.

What the novel and, particularly, the novel of our time is, continues to be a topic of discussion in Europe and among us for two main reasons: the vitality of this literary genre, more alive than ever despite all the funereal forebodings; and its versatility or impurity. The latter word should be in quotes because it is always irrelevant when

not referring to the world of Platonic ideas but to the confused and impure world of human beings. And so, all reflection concerning the purity of poetry, painting, music, and, particularly, the novel, can only end up in windy pedantry. We all know, indeed, what a sinusoid or a geodetic marking is, entities that can and should be defined with absolute rigorousness. As part of the mathematical universe, not only are they pure but they cannot be otherwise. The rough sinusoid that we draw on the blackboard with a piece of chalk is no more than a map to guide our fleshly condition in that transparent Platonic universe, unrelated to the chalk, wood, and hand that clumsily executes the drawing.

But what is a pure novel? Our mania for rationalizing everything, the consequence of a civilization that has believed only in pure Reason, led us to the naive assumption that an Archetype of the elusive genre of the novel exists somewhere, an Archetype that should be spelled, as called for by good philosophical style, with a capital letter; and which naturally insecure writers try to approximate in more or less crude efforts which, to point up their dishonorable degradation, should be designated as "novels" with a small letter.

Regrettably, or fortunately, there is no Archetype. With evident disgust, but with exactitude he never as-

sumed would be taken for praise, Valéry said: "All varia-
tions are within its scope." Of course, simultaneously or
successively, the novel underwent all violations, like the
countries which for that same reason have been fecund in
the history of culture: Italy, France, England, Germany.
And consequently, it was simply narration of facts, analysis
of feelings, notation of social or political vicissitudes. Ideo-
logical or neutral, philosophical or ingenuous, gratuitous
or obligated, there were so many conflicting things that it
had, and has, such an indecipherable complexity that we
know what a novel is if no one asks but begin to hesitate
when they do. What, then, can such disparate works as
Don Quixote, The Trial, Werther, or Joyce's *Ulysses* have
in common?

Philosophy in itself is incapable of bringing about the
synthesis of disassociated man. At most, it can understand
and recommend it. But precisely because of its conceptual
essence it is obliged to conceptually recommend rebellion
against the very concept, with the result that even existen-
tialism itself turns out to be a kind of paradoxical ration-
alism. Authentic rebellion and true synthesis could only
have originated from this spiritual activity that never sep-
arated the inseparable: the novel. By its very hybridity,
halfway between idea and passion, the novel was destined
to actually reintegrate sundered man, at least in his vastest

and most complex undertakings. The synthesis recommended by phenomenological existentialism is achieved in the novel. Neither the pure objectivity of science nor the pure subjectivity of the first rebellion: reality from an ego standpoint; the synthesis between ego and world, between unconscious and conscious, between sensibility and intellect. It is clear that this was possible in our time since, on being freed from scientificist prejudice that weighed on some writers of the last century, the novel proved itself capable not only of providing testimony of the external world and rational structures but of describing the inner world and the most irrational reaches of the human being as well, incorporating into its domains what in other epochs was reserved for magic and mythology. In general, its tendency has been to derive from a simple document what should be called a "metaphysical poem." From Science to Poetry.

As is evident, it is in good measure a matter of readopting the idea of the German romantics who saw in art the supreme synthesis of the spirit. But now bolstered by a more complex conception which, were it not for the grandiloquence of the expression, might well be called "phenomenological neoromanticism." I think that this doctrine could resolve dilemmas in which theory has been exhausting itself: psychological vs. social novel, objective

vs. subjective novel, novel of action vs. novel of ideas. An integrative conception for which there is a corresponding integrality of techniques.

Many of the byzantine discussions on the crisis of the novel are brought about because the problem is formulated in an intrinsically literary manner. I do not think that any clarity is achieved or a clear and valid conclusion reached if the phenomenon of the novel is not presented as the epiphenomenon of an infinitely vaster drama external to literature itself: the drama of this civilization. Its birth, development, and crisis are also the development and crisis of the novel. To examine the problem of fiction solely by way of the altercations of literary cliques, of linguistic or stylistic openings or constraints is to condemn the examination to confusion and triviality. No activity of the spirit and not a single one of its products can be understood and judged in and of itself within the narrow confines of its citizenship: not art, science, nor juridical institutions; and very much less the activity that appears so intimately linked to man's total and mysterious condition, a reflection and sampler of his ideas, anxieties, and hopes, a complete testimonial of the spirit of his time. This does not mean relapsing into the old defect of positivist determinism, which saw in a work of art the result of external factors, a position justly criticized by structuralism. It means that

if the work of art is a structure it should, in turn, be considered an integral part of a much vaster structure which includes it, in the same way that the structure of the melody of a sonata does not "count" in and of itself but only in its inter-relation with the work as a whole.

At this crucial moment one of the most curious of phenomena is taking place. Art is accused of being in crisis, of having dehumanized itself, of having blown up all the bridges that link it to the continent of man. When the opposite is precisely the case, taking as art in crisis what, strictly speaking, is art of the crisis. What happened was that the assumption was based on a fallacy. To Ortega, for example, the dehumanization of art was demonstrated by the divorce of artist and public. Not taking notice that humanity is one thing and quite another the mass public, that complex of human beings that has left off being people to become transformed into mass-produced objects molded by standardized education, crammed into factories and offices, shaken up in daily unison by the news launched from electronic centers, perverted and reified by the industries of comic books and television sagas, journalistic chromos, and gift-shoppe figurines. Although the artist is uniqueness personified thanks to his inability to adapt, his rebelliousness, his madness, he has paradoxically preserved the human being's most precious attributes.

What does it matter that he sometimes exaggerates and cuts off an ear? Even so, he will be closer to concrete man than a level-headed secretary in the bowels of a government office. It is true that the artist, cornered and desperate, ends up fleeing to Africa, to the Edens of alcohol or drugs, to death itself. Does all of this signify that he is the one being dehumanized?

"If our life is sick," wrote Gauguin to Strindberg, "so must our art be, too, and we can only bring it back to health by beginning all over again like children or savages. . . . Your civilization is your sickness."

That which is in crisis is not art but the obsolete bourgeois concept of "reality," the ingenuous belief in external reality. And it is absurd to judge a Van Gogh canvas from that standpoint. When, despite everything, this is done — and how frequently! — all that can be concluded is what is concluded: what is being described is a kind of unreality, figures and objects of a phantasmal territory, products of a man maddened by anguish and loneliness.

The art of each epoch conveys a vision of the world and the concept that that epoch possesses *true reality* and that conception, that vision, is based on a metaphysics and an *ethos* particular to them. To the Egyptians, for example, concerned with eternal life, this transitory universe cannot

constitute the *truly* real one: thus, the hieratic quality of its great statues, the geometric design that is like an indication of eternity, purged to the utmost of naturalistic and terrestrial elements; geometrics that obey a profound concept and is not, as some hastily assume, indicative of technical ineptness since they could be consummately naturalistic when they carved or painted contemptible slaves. In a worldly civilization like that of Pericles, the arts become naturalistic and even the gods themselves are represented in "realistic" form since to such a profane culture, basically concerned with the here and now, this life, reality *par excellence,* "true" reality, is the earthly world. With Christianity there reappears for the same motives a hieratic art removed from the space around us and from the time in which we live. When bourgeois civilization burgeons with a utilitarian class that believes only in this world and its material values, art again returns to naturalism. Now in its twilight, we are present at a violent reaction against bourgeois civilization and its *Welt-anschauung* on the part of artists. Convulsively, often incoherently, it reveals that this concept of reality has reached its end and no longer represents the profoundest anxieties of the human creature.

The novel's objectivism and naturalism were yet another manifestation (paradoxical in its case) of the bour-

geois spirit. That esthetic and that philosophy of narration culminated in Flaubert and Balzac but particularly in Zola, to the point where through them we were acquainted not only with the ideas and vices of the epoch but even with the kinds of rugs they used. Zola carried this style to its reductio ad absurdum and even kept notebooks on his characters in which he wrote down everything from the color of their eyes to how their dress changed with the seasons. Gorky wasted his splendid narrative gifts in part by his adherence to the bourgeois esthetic (which he believed to be proletarian) and asserted that in order to describe one shopkeeper, a hundred had to be studied so as to average out their common features, the scientific method, which permits obtaining the universal by elimination of the particular: pathway of essence, not existence. And if Gorky saves himself almost always from the calamity of putting abstract prototypes on the stage instead of living types, it is despite his esthetic not because of it; because of his narrative instinct and not his ill-chosen philosophy.

Many decades before Gorky was to give himself over to this conception, Dostoyevsky ended by destroying it and opening the sluices of all of today's literature in *Notes from the Underground.* Not only did he rebel against the trivial objective reality of the bourgeois but on plumbing the depths of the tenebrous abysses of the ego, he found

that the intimacy of man has nothing to do with reason, logic, science, or much-vaunted technology.

That displacement towards the depths of the ego was soon generalized in all the great literature that followed.

SCIENTIFIC UNIVERSALITY AND
ARTISTIC INDIVIDUALITY

HENRI POINCARÉ SAID with elegance that mathematics is the art of reasoning correctly with incorrect figures. Inasmuch as nobody claims, nor is it necessary to, that the right-angle triangle drawn on a blackboard is the authentic Platonic triangle for which the theorem is applicable, it is barely a crude suggestion, a rough map to guide reasoning.

A completely contrary situation exists in art, in which precisely what is important is the personal and unique diagram, the concrete expression of the individual. And if it achieves universality, it is the concrete universality that is attained not by shunning individuality but by bedeviling it. What is more disturbingly personal than a Van Gogh canvas?

Science can and should disregard the ego, art cannot. And it is useless for it to be proposed as a duty. Fichte made an observation to the effect that in art objects are creations of the spirit, the ego is the subject and, at the

same time, the object. Beaudelaire, in *Art Romantique,* asserted that pure art is the creation of an allusive magic that involves the artist in the world around him. He went on to say:

> *We lend a tree our passion, desires, or melancholy;*
> *its groaning and nodding are ours and quite soon we*
> *are that tree. Likewise, a bird soaring in the sky is*
> *the immediate representation of our immortal*
> *yearning to soar above human things; we are, then,*
> *that very bird.*

Byron said the same: "Are not mountains, waves and skies a part of me and my soul, as I of them?"

What are those mysterious grottoes behind Leonardo's figures, those bluish and enigmatic dolomites behind the ambiguous faces, but the indirect expression of the spirit of Leonardo himself? In the way the movements and gestures of an actor unrelated to Shakespeare's life nonetheless make him into Hamlet and hence Shakespeare when he is animated by the fiction of the Prince of Denmark. And it is in this sense that Leonardo's famous aphorism, which said that painting is a mental matter, should be interpreted since to him "mental" meant not something merely intellectual but something subjective, something characteristic of the artist and not of the land-

scape he paints. To him, art was an "idealism of matter."
How, then, ask objectivism of art?

It would be like asking the Opus 135 Quartet *not to
seem like* Beethoven's. And since for great art it is not a
matter of seeming but of being, it would be as absurd as
asking that it *not be* Beethoven's.

This objectivist doctrine can be explained only as a
consequence of the prestige and imperialism of science,
of the dogmatic belief in an external universe that the
artist, like the scientist, must describe with the same cold
impartiality. So, the writer of novels would describe a man's
life or vicissitudes in the way a zoologist does termites,
investigating the laws of those societies, describing their
customs and dwellings, their languages and nuptial dances.
And, as has been pointedly remarked, the third-person
narration of these stories was similar to the third person
in which the customs and nature of mammals and reptiles
were described in natural science books. And even when
that objective reality was distorted or transfigured, such
distortions or alterations were the product of simple dif-
ferences of style or verbal technique (generally reprehen-
sible) and not of reality. At no time was it conceivable to
him that the reality of one could in any way be the reality
of another, although it is obvious that Balzac-world reality
is not the same as Flaubert-world reality. The present-day

novelist, however, is not only already aware of that decisive fact but also that reality differs *for each character* as well: in accordance with the variance in how he sees it, his viewpoint, what he gives to the external world and what he gets from it.

In synthesis: If by reality we understand, as we should, the external reality that science and reason tells us of but *also* that dark world of our very spirit (infinitely more important, besides, for literature than the other), we come to the conclusion that the most realistic writers are the ones who, rather than concern themselves with the trivial description of customs and costumes, describe sentiments, passions, and ideas, the corners of the unconscious and subconscious world of their characters, an activity that not only does not imply abandonment of that external world but is the only one that makes it possible to define for the human being his true dimension and scope, since all that matters for man is that which most deeply and intimately relates to his spirit: that landscape, these beings, those revolutions that in one way or another he sees, feels, and suffers in his soul. And so it is that the great "subjective" artists who did not assign themselves the silly task of describing the external world were the ones who left us the truest, most intense pictures and testimonials of it. While the mediocre practitioners of the literature of man-

ners, who accused them of circumscribing themselves to their own egos, did not even achieve what they set out to.

The words "chair" or "window" or "clock," are spoken, indicating mere objects of that frigid, indifferent world that surrounds us and, nevertheless, suddenly we transmit something mysterious and indefinable with those words, something that is like a code, like a poignant message from somewhere deep in our being. We say "chair" and do not mean "chair," but we are understood. Or, at least, the cryptic message, passing unaffected through the indifferent or hostile multitudes, is understood by those to whom it is addressed. And so, that pair of wooden shoes, that candle, that chair mean neither those wooden shoes, that wan candle, nor that straw-bottomed chair but, rather, me, Van Gogh, Vincent (particularly, Vincent): my anxiety, my anguish, my loneliness; and so they are rather my self-portrait, a description of my profoundest and most painful anxieties. Making use of those external and indifferent objects, the objects of that rigid and cold world outside us, that was perhaps present before we were and which will very likely be there after we are dead, as if those objects were no more than temporary, shaky bridges (like words for the poet) for crossing the abyss that opens between us and the universe. As if they were symbols of the profundity and reconditeness they

reflect: indifferent, objective, and gray for those unable to understand the code, but warm and taut and charged with secret meaning for those who know it. Because, actually, those painted objects are not universes of that indifferent universe but objects created by the solitary and despairing being, eager to communicate, who does with objects the same as the soul does with the body: impregnating it with his yearnings and sentiments, manifesting himself through the wrinkles, the gleam of his eyes, the smiles and corners of the mouth; like a spirit that tries to manifest itself (desperately) through the strange, sometimes grossly strange, body of a hysterical medium.

Style makes the man, the individual, the one-of-a-kind: his way of seeing and feeling the universe, his way of "thinking" reality, that is, blending his thoughts with his emotions and sentiments, his type of sensibility, his prejudices and manias, his tics.

It makes no sense, then, to refer to Pythagoras's style in his theorem. The language of pure science can and, rigorously speaking, must be replaced by pure and abstract symbols, as impersonal as the Platonic figures to which they refer. Science is generic and art is individual, and that is why there is style in art and not in science. Art is the way one who has an intense and curious sensibility looks at the world, a way that is peculiar to each of its creators

Ernesto Sábato

and non-transferrable.

Rhetoricians consider style adornment, a festive language. In truth, it is the only way in which an artist can say what he has to say. If the result is unusual, it is not because the language is, but because that man's way of looking at the world is.

THE NOVEL OF CRISIS

78 (23)

TWO SUSPECT WORDS

" SUBJECTIVE, " LIKE " METAPHYSICAL, " is one of those words that nobody can utilize without being immediately branded in the name of Marx an obscurantist and reactionary. Actually, not only existentialism but Marxism springs from concrete man (the only kind that exists) which is tantamount to saying that they spring from subjectivity. And this conception dignifies man, since it is the only one that does not consider him an object. Mechanical materialisms, on the contrary, among which must be included this kind of materialist Marxism, regards man to be the resultant of a composite of determinants, as is the case with an atom, stone, or table, ruled by blind causality alone. The crude paralogism that makes those critics wary of those who speak of subjectivity probably consists of imagining that to lend importance to the ego implies turning one's back on social reality and becoming a sort of ontological masturbator. In other words: Out there, steel strikes; here, the egocentric solipsist bottled up in his own

ego.

But to existentialism, as to true Marxism also, subjectivity is not rigorously and definitively individual, inasmuch as in the *cogito* man not only discovers himself but the others; contrary to the thought of Descartes and Kant, man finds himself vis-à-vis the Other, and the Other is as definite for him as he himself is. The discovery of the intimacy of one's self is also, dialectically, the discovery of the other intimacy, that of the one opposite you, living with you, suffering and talking with you, working with you, communing with you via language, gesture, hate and love, art or religious feelings. This intersubjectivity, this interweaving of subjects that constitutes human existence, is occurring at every instant through man's activity, through praxis, which is the reality of man and his history. There is no abyss, then, between subject and object. And those materialists who overestimate the object to the point of considering it as "the" reality, are as metaphysical (to use the word in the Marxist sense) as the others who believe that "the" reality is solely that of the subject.

Metaphysics, as Merleau-Ponty maintains, reduced by Kantianism to a system of principles that reason employs in the construction of science or the moral universe, although radically negated by positivism for that function, has not ceased to carry on a sort of illegal life in literature

and that is the situation in which critics today inevitably come up against it. For example, we read in *Rimbaud* by Etièmble y Gauclère, that: "Metaphysics is not necessarily the fallacious association of noumena; Rimbaud felt this to be so more intensely than anybody, reconstructed a metaphysics of the concrete, saw things in themselves, flowers in themselves."

It may be argued that this is excessively free usage of such words as phenomenon and *ding an sich,* and it would be in place to discuss the possibility of art achieving the absolute. Here, I would only say that the word metaphysical is used in the same sense that Sartre uses it in *Being and Nothingness,* linked to man's concrete totality. Concrete totality — a basic category not only for existentialism but also for Marxism — that seems unattainable by pure thought and which, on the other hand, may be attained by the total activity of the human spirit, and very specially by the work of art. For that reason we should not be surprised that philosophers, when really striving to touch the absolute, have had to resort to art. In the case of the existentialists, they were obliged to write novels and plays. But we can detect the same impulse even in those philosophers who came before existentialism. Plato resorted to poetry and myth to round out the description of the dialectical movement that brought us to Ideas; and Hegel

uses myths like those of Don Juan and Faust to make the drama of anguished conscience intuitable, a drama that takes on meaning only in the concrete and historical world that man inhabits. In short, the metaphysical viewpoint as has been put forward since the advent of existentialism is perhaps the only one that admits conciliation of man's concrete totality and is, particularly, the sole form of conciliating the psychological and the social. A totality in which man is defined by his metaphysical dimension, by that conjoint of attributes that characterizes the human condition: his yearning for the absolute, will to power, impulse to rebel, anguish over loneliness and death. Attributes which, although manifested in concrete man of one time and place, have the permanence of man of all times and societies. This is the reason why the plays of Sophocles continue to move and shatter us even though the societies in which they came into being and of which they were in some form the manifestation have disappeared: the only valid explanation of the problem formulated by Marx but left fruitlessly unresolved, perhaps because of his reluctance to admit metahistorical values in man.

SURREALISM

IT WAS NOT CASUAL that I should have been drawn to surrealism when in 1938 my weariness and even disgust with the scientific spirit reached its limit. And so, I would spend my day working at the Curie Laboratory and at night I joined that true surrealist, Domínguez, who ended by committing suicide after he entered a mental institution. But I was able to appreciate all of the movement's grandeur and its poverty.

In Switzerland, that quintessence of the bourgeois spirit, Dada was launched by Tristan Tzara in 1916. Those moralizing spirits charged with veritable frenzy against the commonplaces and hypocrisy of an outworn society. Bourgeois reason was targeted as the principal enemy, and first Dadaism, then surrealism, its heir, directed their attacks at it. The great epoch of that insurrection lasted until the appearance of the second manifesto in 1930. At that point, the slow decline set in and by the time I met Domínguez and then Breton, it was evident that the death throes had

begun.

The romantics had already set reason against poetry, as night opposes day. But the surrealists carried this orientation to its ultimate. For Breton, the more absurd the image, the more valid. Thus, the invocation of automatism, of imagination freed of all rational impediment. Also, therefore, their contempt for standards, the classics, and libraries. Surrealism placed itself outside esthetics and even art. It was rather a general approach to life, a seeking for profoundest man beneath outworn convention. How was it possible not to admire Freud and Sade, primitives and savages?

Paradoxically, however, it was transformed into a method for obtaining a new class of beauty, a kind of savage-state beauty. Likewise, a new morality, the morality that is left after all the masks superimposed by a cowardly and hypocritical society have been stripped away, a morality of instinct and dream. Like it or not, a surrealist esthetic and a surrealist ethic were created.

But, upon crystallization into manifestos and recipes, decadence set in. For, generally, there is no conservatism worse than that of victorious revolutionaries. The search for savage authenticity spawned a new academicism whose paradigm was Salvador Dalí, a charlatan who, after all, was a product of surrealism and who, in a way, displayed its

worst attributes. And if it is unfair to judge the movement solely on the basis of such specimens, as many do, equally unacceptable is the demand by certain surrealists that the movement be judged without including that clown. It is not by chance that such a man as Dalí should have arisen in surrealism and, when all is said and done, he did enjoy the blessings of his pontiff for attributes that were neither more nor less than those he possessed to the end.

The truth is that all too frequently the movement was prone to humbuggery; the truly "possessed" were rare and very few ended in the madhouse like the great Artaud.

Nor is the grandiloquence that usually characterizes its followers due to mere chance since falsification of substance almost always goes hand in hand with pomposity of form. Such rhetoric, already one of the worst calamities that beset romanticism, reappeared in surrealists who thought thereby to *épater le bourgeois,* and ended up sickening its true poets. As in the case of a genuine romantic like Stendhal who determined to write in the dry language of mathematics and law; the disgust felt by a true religious spirit for sanctimony and the parasites of religion.

But there is something authentic in surrealism that continues to maintain its validity and which, in a certain way, prolongs and deepens the existentialist movement: the conviction that the dominance of mere literature and

mere art has ended, that the moment has come for taking a position beyond pure esthetic concern to grapple with the problems of man and his destiny. The task of liberation initiated by romanticism and carried on against a hypocritical and conventional society continues to be the prerequisite for the reformulation of the human condition in our time and, particularly, through granting art and literature their due place. The terrorism of the surrealists was necessary for undertaking any enterprise of reconstruction. The tin gods of bourgeois society with their hypocritical morality, Philistinism, opportunism, and superficial optimism had to topple once and for all in order to open the doors to a more profound way of life. Ours is a time of despair and anguish and only in that way will new and authentic hope arise. The error lies in believing that this first phase of pure destruction and pure irrationality is sufficient in itself, since man is also, and fundamentally, subordination of the "I" and its instincts to the "us," the community and dialogue. It was inevitable that once the destructive task had been realized, surrealism would fall into decline and be transformed into a paradoxical academy. An academy of surrealism would be something like a council on good manners in hell.

In 1938, when I consorted with them, they were already living on memories, and schoolboy orthodoxy had

taken over from the anarchistic drive of the heroic days. At the end of World War I it was necessary to dispel many of the sinister myths of commercial civilization. But by the end of World War II, those myths had already been shattered. And man had seen too many catastrophes and ruins not to feel a need to build. There had already been quite enough desolation to make it evident through the huge cracks in a devastated world what the new responsibilities of the human animal would be. As somebody said, shouting was no longer enough to throw a scare into the bourgeois, nor even going crazy. It was a matter of taking on the difficult task of building afresh, even if it were to be done amidst darkness and despair. It was not enough to advocate simple irrationality which, after all, the Gestapo had practiced more effectively than they. It was essential to realize that if man was not pure rationality, as a mechanistic society pretended, neither was he pure irrationality. And if man was not reducible to simple reason, neither was he reducible to pure instinct.

The time for a new synthesis had finally come.

THE NOVEL AND PHENOMENOLOGY

DOCTRINES DO NOT APPEAR HAPHAZARDLY. On the one hand, they prolong and deepen the dialogue they maintain throughout the ages and, on the other, they are the expression of the epoch in which they are put forward. As a stoic philosophy is always born under despotism, as Marxism expresses the spirit of a society giving violent birth to industrialization, so existentialism translated the anxieties of man undergoing the collapse of a technology-venerating civilization. Which does not mean that it is translated univocally and literally, since a doctrine is elaborated in complex and always polemical fashion.

The *Zeitgeist* philosophically manifested in existentialism made its appearance in literature in the type of creation that came into being essentially with Dostoyevsky. It was a faithful correlate in the field of letters of that philosophical trend, to the point where many superficially asserted that "literature has turned existentialist," when actually the literature arose spontaneously a century before this came

into fashion. And, it is not so much that literature has encroached on philosophy but rather the other way around. The novel was always anthropocentric whereas it was precisely with existentialism that the philosophers turned to concrete man.

But the more profound truth is that both activities of the spirit coincided at the same point and for the same reasons. With the difference that while that transit was easy for novelists who had only to accentuate the problematic character of their eternal protagonist, it was a very arduous task for the philosophers inasmuch as they had to come down from their abstract speculations to the dilemmas of concrete being. Be that as it may, at the same moment that literature turned metaphysical with Dostoyevsky, metaphysics turned literary with Kierkegaard.

Now, if the return to the ego and the rebellion against reason is the touchstone and initiation of the new modality, it is not true, as many superficial critics assume, that the process ends there. In the face of the extremes of reason, vitalism healthily championed life and its instincts. But the explosion in World War I of the more primitive and violent of the instincts, on reaching its extremes, could not but arouse a hunger for spiritualization that became more acute at the end of World War II with its concentration camps. This is one of the causes responsible for existentialism's

distancing itself from simple vitalism, without abdicating for that reason defense of concrete man. Man was not, in the final analysis, either pure and simple reason or mere instinct. Both attributes had to be integrated with the supreme spiritual values that distinguish man from the animals. Since Husserl, philosophy was no longer to center in the individual (wholly subjective), but in the person (synthesis of individual and community).

Philosophy and the present-day novel represent that synthesis of opposites, something like the synthesis of lyrical poetry and rationalist philosophy.

After Husserl's discovery, philosophy ceased taking the exact and natural sciences as a model, the sciences that operate on concepts obtained by abstraction from particular facts. In this way philosophy approached literature, inasmuch as the novel had never abandoned (not even in the worst periods of scientism) concrete reality just as it is, in its rich, variable, and contradictory condition. As was said of the poet contemplating a tree and describing the movement produced by the wind in its leaves: He does not make a physical analysis of the phenomenon, resort to principles of dynamics, nor reason through mathematical laws on light programming but concerns himself with the pure phenomenon, the warm and glowing impression, the pure, beautiful sheen and tremor of the leaves rustling

in the wind.

Thus, what is literary description but pure phenomenology? And hasn't the philosophy of concrete man produced by our century in which body cannot be separated from soul, nor consciousness from the external world, nor my own ego from the other egos that consort with me, been the tacit philosophy, albeit imperfect and perniciously falsified by the scientific mentality, of the poet and the novelist?

ROBBE-GRILLET'S CLAIMS

I f Robbe-Grillet had confined himself to writing his tales there would be no reason for complaint; rather, his presence should be pointed out as one of the most curious culminations of certain contemporary trends. Regrettably, his literature is coupled with a totalitarian and even terrorist doctrine that seeks to turn other narrators into misguided and forsaken fauna. That being the case, we are justified in saying what we think of his theories.

Robbe-Grillet has two ways of constructing a narration. In the first, in the murky protohistory that preceded his revelation, the writer seeks to plumb the soul of his characters through psychological analysis, decomposing consciousness like a chemist does an unknown substance. Aware that this is a fallacious exercise, he limits himself in the second, to providing an external vision of fictional beings, objectively recording like a movie camera the outlines of faces, voices and gestures, silences and distances, the objects they use or that surround them. The narrator,

like any reader, makes no judgement as to what may happen within those opaque beings, nor vainly tries to determine what there might be beyond that description of behavior and the circumstances.

Let us begin by asking ourselves if it is obligatory to choose between an analytical and a behavioristic literature.

Psychological analysis is the end result of an atomistic conception of reality that science has been imposing since the Renaissance. Abstract conception derived from physics committed at least two serious errors insofar as the human being is concerned: that of imagining man as the atom — the "individual" — of society, and that of assuming that his conscience was a compound that could be analyzed like a chemical substance.

By considering man in his overall conduct, behaviorism does not repeat the error of atomism but on the other hand, declines to investigate the internal structures of conscience, the complexes and life experiences that are not necessarily learned through behavior. In observing the behavior of a writer who is composing a page we are never able to know his sentiments and ideas, how he feels about the world, his concept of existence.

To enter into a human being's soul or that of a character in a novel does not necessarily imply doing so by means of analytical method. If I am a scientist who

studies monkeys, I naturally do so with the only source of information at my disposal: their movements in looking for a banana, how they pick it up and peel it, eventual quarrels with companions, and so on. If I am a psychologist who intends to investigate man, it would be quite foolish of me to limit myself to the methodology specific for monkeys or mice inasmuch as I have other valuable approaches at my disposal: asking my subject what he thinks and feels, hearing his dreams, getting him to talk under drugs or hypnosis. But if I am a novelist, then vaunted behaviorism is now no longer an absurd renunciation but a mere fallacy, since the characters emerge from the creator's own heart and although he does not thoroughly "know" them, for the same reason that nobody fully knows himself, he lives them from within and not from without; and although they escape his will like oneiric phantasies, they also belong to him as those phantasies.

That is to say, there is no need to proceed from atoms to monkeys. Man is not an atom and we were aware of that. But neither is he a monkey. And I see no advantage in writing novels as if he were.

The real dilemma, therefore, is not this but that of a mistaken analytical conception vis-à-vis a conception that might be called phenomenological-structural. The German romantics had already rejected atomism in the compass of

the human being, proposing communities of man and the psychic complexes as structures irreducible to their parts. It is not possible now to go on maintaining the absolute separation of subject and object. And the novelist must give the *total* description of the interaction between consciousness and the world that is peculiar to existence.

In accordance with the doctrine of exclusion it is hard to understand why Robbe-Grillet wrote novels like *La Jalousie.* A novel in which the creator — and the word "creator" would now have to be replaced by another — does not intervene with his particular viewpoint and his own opinions would have to be a vast, or I should say, *total* description of the universe, of all that is possible to see, touch, smell, taste, and feel in order not to depart from the sensory basis of the doctrine. Any choice of one topic rather than another, of a given character, of a particular drama would be an intolerable intervention on the part of the author, much less tolerable than the extremely modest interventions that Robbe-Grillet denounces in writers who do practice his theory.

Of course, despite what he says in his manifestos, he has to curb himself in practice. He does not carry out his grandiose pantheistic program and limits himself to giving us a particular drama in a particular little locale: a slight intervention on the part of the author.

We are present, then, in an African village and have a pair of lovers before us. We have sensibly excluded zebras and beetles, gas stations, and young children, buses, and prie-dieus of the good old days mentioned in the above orthodoxy. There is nothing to become: the work of art is an attempt to present infinite reality within finite dimensions. That we knew. What we did not expect is that Robbe-Grillet would be part of that anomaly.

We are before a pair of lovers or supposed lovers, watching them from the bitter point of view of the cuckold. What should we expect, then? It is well known that a man eaten up by jealousy is not one who is most inclined to regard the cosmos with equanimity. It is impossible to demand of him that he observe and describe at a given moment the distance between the lovers' hands in the shadow with the same minuteness as the dimensions of the trellis in a nearby tomato patch. Surprising as it may seem, the author does grant his hero this placid wide screen capability. To be sure, with the guilty conscience of having intervened in the choice of a village, three characters, and a drama, he must prove in some way that he is hewing to his doctrine of unselective description by offering us equally precise data on the woman's position with respect to the topographical location of the suspicious onlooker as on agricultural development in Central Africa.

Furthermore, it can be accepted that the hero of *La Jalousie* should describe from outside the *other* characters of the narration, that from his point of view he could not deduce or induce the thoughts of his wife (despite that long conversation known as marriage), her intentions, her secret purposes. And let us admit, with more reason, that neither can the thoughts and purposes of the supposed lover be inferred. However, what kind of psychology prevents the hero from describing his own, well-known presumptions? Who is stopping him from using his ideas, his reasoning, his assumptions? Is he perhaps a monkey, a guinea pig? Or, at least, feebleminded? Whoever heard of a person, jealous or not, and particularly when he is jealous, who does not reason interminably, mull over his suspicions, ponder what he sees or surmises? In the name of what objectivity is all this dispensed with?

There is yet a last philosophical inconsistency. The characters of these narrations only see and feel. But man is something more than a sensory subject; he has will power, organizes, and abstracts his experiences, always ending by elevating himself to the level of ideas. In no way is he a passive movie camera or, in the best of cases, a "panesthetic" apparatus, but he proceeds to arrange those sensory data into forms, gradually converting the chaos into structures. When a novelist who seeks to do without

all that is not mere sensation pronounces a simple sentence like "he saw a cat," he forgets that the noun "cat" is a universal, product of abstraction and, hence, inadmissible for use in his effort. To be consistent with his total empiricism, he should have replaced it with words that represent a series (infinite) of "cattish" images. And further, he should exclude sentences of that kind organized in keeping with a syntax that is foreign to a purely sensory subject, to simple natural or zoological consciousness. In other words, he should give up literature. For that reason, undoubtedly, there is no known chimpanzee novelist.

Man is not that simple psychic subject but an eidetic animal that emerges from the chaos of the senses to the order of ideal objects. How can a protagonist unable to apprehend beauty and justice (since he has been deprived of his emotional intuition), unconscious of his solitude or community, of his finiteness or mortality, of the absence or presence of God (since neither does he have metaphysical intuitions) be considered not only the only legitimate type of character for a novel, but the spokesman of great present-day literature?

It might seem pointless to recall the constant alternation of subjective and objective in art's course. Nevertheless, this doctrine forces us to do so in order to show the transitoriness of so many similar movements. The romantic

rebellion arose in counteraction to the scientific spirit of the Enlightenment. When the new style degenerated into cheap sentimentalism, the apologia of the cold objectivity of "resistant matter," of impersonality was resumed. One did not have to be a seer to prophesy that out of the very heart of that neoclassicism there would emerge the elements for a new romanticism that would pass from marble to aleatory music, and from literal expression to obscure symbol. And so on *ad infinitum.*

At the close of World War I, serious artists became fed up with the grandiloquence that marked expressionism's end, and once again there was a call for a return to formal severity, impassive objectivity. With the initiation of that *Neue Sachlichkeit,* that New Objectivity, which, nevertheless, would have been more appropriately called "magical realism," as Franz Roth so prudently did, there came realization of the fallacy implicit in speaking of objectivity in art. As Erich von Kahler fairly observes, we see a cruel and implacable insistence on facts in the paintings of Chirico or de Carrá, an exhibition of the object in its inexorable sameness, producing something like an inverse emotion that emanates silently and magically in the same way that a violent rebellion of man is expressed through an almost pure statement in the early works of Brecht. But in none of them, nor in the Kafka who redou-

bled the horror of his nightmares through the calm with which he described them, nor in laconic and stripped-down Hemingway, is there objectivity in the strict philosophical sense but rather an inversely effective form of manifesting the highly particular manner each of these creators had of feeling the world to the point where we are able to pick out a painting by Chirico or a novel by Kafka among thousands of works.

In summary, "objectivism" is a reiterated trend in the dialectic of schools. And, in its nonrigorous sense, it has been utilized by artists whenever they considered it effective to do so, on all occasions that their expressive needs called for it, not out of totalitarian mania.

The same is true insofar as language is concerned. Robbe-Grillet's antimetaphorical fury, his idea that figurative language is inadmissible, can only be explained by his philosophical incoherence and great arrogance. We have known since Vico that metaphor is not adornment nor swollen language nor the jewel that Latin rhetoricians assumed it to be, but the only way man has of expressing the subjective world. The strict objectivity of science calls for a univocal and literal language that culminates in the tranquil parading of symbols of mathematical logic. But that language is of no use to concrete man. First, because existence is not logical and cannot make use of unequivocal

symbols created to fit the principles of identity and contradiction, and then, because concrete man doesn't only, or doesn't even, propose to communicate abstract truths but sentiments and emotions, seeking to act upon the spirit of others, moving them to sympathy or hatred, action or contemplation. He uses an absurd, contradictory but powerful language for this purpose, a language that changes and replaces hackneyed words and expressions which in being outworn are psychologically inoperable with new and striking modes, with combinations that attract in their unexpectedness. The mission of this language is not to communicate abstract and indisputable truths of logic or mathematics but the truths of existence linked to faith or illusion, to hope or fear, anguish or passionate conviction. Its drama is the inverse of science's since it must express unique facts with general words, with commonplaces that have neither blood nor power of conviction. Whence, then, the tireless, reinvigorating effect that life brings to bear upon language through imagination and metaphor. An effort that culminates in poets who, like Joyce, strive to create a language in a budding state through alternation of meaning, rupture of syntax, simple onomatopoeia. Since, despite everything, language is an instrument of communication, arbitrariness is limited by the need to refrain from blowing up bridges, and so language evolves

in a permanent dialectic between the commonplace (which tends to become passé) and the out-of-place (which tends towards pure arbitrariness). And the dissolution that is an ever present threat in those revitalizing movements is always followed by new discipline. It is understood that the time comes in this, too, when some writers put forward scientific language as a paradigm, a recommendation that should be taken with due precaution, due relativity, and in full awareness of its unrigorous and simply hygienic sense.

Two types of vicissitudes in art can be observed throughout history: those that are the resultant of or form part of the inner dynamic, such as the battle against cliques and schools, the weariness of trends, the exhaustion of certain forms or procedures, the reiterated tendency to parricide; and, those that make up part of the great historical structures, structures that involve a given conception of existence, an ethos, a metaphysics — of medieval religious man, of the profane Renaissance bourgeois, of man of our own time.

Insofar as the first type of vicissitude is concerned, the Robbe-Grillet school is a neoclassical type of movement, always with the advantages and disadvantages of reactions of that type of movement vis-à-vis romantic excess. But its absolutism and durability is as illusory as that

of any other similar movement in the foregoing times.

Regarding the great arcs of history, however, it is evident that despite its reaction against *one* aspect of the scientific mentality, it is a literary manifestation of scientific mentality, albeit in a scholastic and inconsequential way. Modern Times are, in fact, typified by science, its great paradigm being the Object, and objectivity is generally the concern of spirits dominated by that mode of looking at the world.

True art is rebellion against this moribund culture and, therefore, cannot be any type of objectivism but rather an integralist art that allows description of the subject-object totality, the profound and inextricable relation that exists between the ego and the world, between consciousness and the universe of things and man. From this standpoint, the novel heralded by Robbe-Grillet does not represent the future as its inventor naively supposes, but the reductio ad absurdum of a mentality in liquidation, although it does struggle to free itself by reacting against one of its more precarious manifestations: psychological analysis. Only in that measure and in that sense can it be considered a co-participant in the vast movement that must overcome scientific fetishism.

Quite a modest participation, to be sure.

Ernesto Sábato

This essay appeared in 1963 in the magazine Sur *at the time the doctrine of objectivism was at its height.*
— Translator's Note

FLAUBERT AND OBJECTIVISM

THE FRENCH PUBLIC was awaiting a Cervantes who would do for the treacly romanticism of novels of love what the great Spaniard had done with the novels of chivalry. And Flaubert made ready for the sacrifice, not despite his being a romantic himself but precisely because he was one, as a mystic is capable of planting a bomb in a perverted church.

Thus arises one of the most pertinacious misunderstandings of the novel form, that concerning its objectivity. So pertinacious that the *Nouveau Roman* proclaimed Flaubert its patron. It is not surprising that this illusion should have possessed men of that period — it was the heyday of science. That the illusion should have spread to the sophisticated narrators of Paris today is indeed quaint. But it is true that errors are usually more pertinacious than truths.

Poor Flaubert. The man who said "My imaginary characters affect me, pursue me, or rather, it is I who is

in them."

Besides, the creator is in everything not only his characters: he has *chosen* that drama, that situation, that town, that landscape. And when he writes, "On remembrance of Rodolphe, she had brought him into the very depths of her heart, and there he remained, more solemn and more immobile than a royal mummy in a crypt," could poor Emma be thus capable of describing the corpse of her passion?

THE NOVEL OF CRISIS

THIRTY YEARS AGO, T.S. ELIOT asserted that the genre of the novel had ended with Flaubert and Henry James. This funereal judgement was repeated by various essayists in one form or another.

It often happens that transformation is confused with decadence because the new is judged according to criteria that served for the old. Thus, when some maintain that "the nineteenth century is the great century of the novel," it should be amended by the words "the nineteenth century novel" which would make the aphorism rigorously accurate but at the same time, thoroughly tautological.

It is quite extraordinary that an evaluation of twentieth century fiction should be attempted using canons of the nineteenth century, a century in which the type of reality described by the novelist was as different from ours as a treatise on phrenology from a paper by Jung (and for very analogous reasons). And, if classification of literary work into categories has always been a task destined for

failure, it is notably useless as far as the novel is concerned since it is a category whose sole characteristic is that of having possessed all characteristics and suffered all violations.

The twentieth-century novel not only provides an account of a more complex and truer reality than that of the previous century, but has also acquired a metaphysical dimension it did not possess before. Loneliness, the absurd and death, hope and despair are perennial themes of all great literature. It is evident, however, that this general crisis of civilization was necessary for it to have acquired its terrible timeliness in the way that when a ship is sinking the passengers abandon their games and frivolities to face the great final problems which were nevertheless latent in their ordinary lives. The novel of today, because it is the novel of man in crisis, is the novel of those great Pascalian themes. And, consequently, not only has it launched itself on the exploration of territories not even suspected by those novelists but it has taken on philosophic and cognitive dignity.

How is it possible to consider in decadence a genre with such discoveries, such vast and mysterious domains to cover, with the consequent technical enrichment, its philosophical transcendency, and what it represents for anguished man of today who sees in the novel not only

his drama but seeks its guidance? On the other hand, I think that it is the most complex activity of today's spirit, the most integral and promising in this effort to investigate and express the drama that has been our lot to live.

ART AND SOCIETY

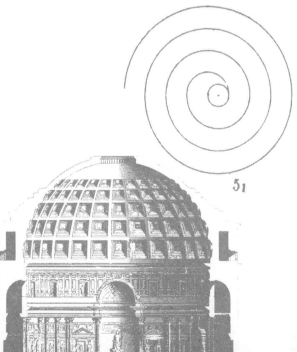

5_1

THE FAMOUS COMPROMISE

CONFUCIUS APPRECIATED ART solely for the services it could render the state. Plato permitted only poems in honor of illustrious forebears and gods, and in the *Laws* he prohibited all art not useful to the Republic.

But the phenomenon is accentuated in the great revolutions, which is understandable: those rebels are always dangerous to the state. Why be surprised at the grotesque extremes of Stalinist Russia? Rousseau had already denounced the corrupt nature of art. Saint-Just, in the Feast of Reason, demands that reason be personified by one in whom virtue takes precedence over beauty. The Revolution demolished art and produced no important writer, guillotining one of the few poets of its time, while on other stages plays with such titles as *Virgin and Republican* were presented. The Saint-Simonians called for a "socially useful" art and progressives the world over demanded that artistic creativity be at the service of humanity's development, the Russian Nihilists going so far as to proclaim that

a pair of boots was more useful than all of Shakespeare.

It should not come as a surprise to us that in this time of total crisis certain revolutionaries should call for a "social" art.

Before accusations are leveled at us, remember that Karl Marx, who recited Shakespeare and the British lyric poets from memory, admired the monarchist Balzac and bowed down before a courtier named Goethe, ridiculed the "social" work entitled *L'Insurgé* that was written by a revolutionary of the Paris Commune.

ART AND SOCIETY

ART IS INEVITABLY related in some way to society since art is made by man, and man (even a genius) is not isolated — he lives, thinks, and feels in relation to his circumstances.

The phrase "in some way" implies a kind of infinitely more complex and subtle link than the familiar "reflection." According to that doctrine which seeks to be realistic but which, rigorously speaking, is fantastic, art is a reflection of the society in which it appears. In the most caricatural of cases, it is even asserted that it reflects the economic and class conditions. These doctrinaires who usually call themselves Marxists have not considered, apparently, that if this theory were correct it would not even be able to account for Marxism itself, propounded by the bourgeois intellectual Karl Marx living, as did his collaborator, the industrialist Engels, in a typically bourgeois society, the inheritors, consciously and proudly, of a great culture, also bourgeois. How could they have invented or

discovered the theory of proletarian revolution?

It does not seem that such a caricature could be taken seriously. Nevertheless, it has validity, carries out analysis, makes recommendations, launches accusations all the time. Lenin himself told Gorky, apropos of Tolstoy, that "never had a muzhik been so profoundly described before this count came on the scene": a lesson that, nevertheless, seems to have made no impression even upon Gorky himself, who invented socialist realism.

No doubt about it, there is some relation between the artist and his circumstances and it is clear that Proust could not have developed in an Eskimo tribe. Sometimes there is a clear link, such as that between the appearance of the bourgeois class and the introduction of proportion and perspective in painting. But most of the time that link is much more complex and largely contradictory since the artist is generally a nonconforming and antagonistic being and because, in good measure, it is precisely his disaffection with the reality he has lived that leads him to create another reality in his art which is as far-removed from it as a daydream, and for similar reasons. Man is not a passive object and, therefore, incapable of limiting himself to reflecting the world. He is a dialectical being and (as his dreams bear witness), far from reflecting it, he resists and contradicts it. And this generalized attribute of man ap-

pears with more hysterical acuteness in the artist, an anarchic and antisocial individual, for the most part, a dreamer and maladjusted.

If that is not the case, how explain so many contradictions? In the very salons of the eighteenth century, men who belonged to that same refined and decadent society, celebrated and admired writers, engendered books that paved the way for that same society's destruction. And not even coherently, not even in one clearly defined band, but in movements as contradictory as Rousseau's naturalism and the scientific rationalism of the Encyclopedists.

The Revolution soon came and it was David's reactionary and neoclassical painting that officially represented it, an art that was to terminate ridiculously with the famous firemen's helmets. Superficial art like all conformist and official art. While the great and true artists will, as always, produce a refractory and heretical creation. Literature, and literature in particular, is something like the inverse of society. In theocratic periods it is frequently anticlerical, as the medieval *fabliaux* indicate. And, obversely, never is such profoundly religious literature produced as in secular periods. Consider the quality of the Catholic literature in France of the Third Republic or in Protestant England of today.

Marxism has little to do with the materialism that

reduces the entire activity of the spirit to economic forces, inasmuch as in that scheme man is not free but the slave of those forces. Marx proclaimed exactly the opposite. In the *Critique of Hegel's Philosophy of Law,* for example, he asserts that the active force is not history but real, living man who pursues his own ends. It is true that many Marxists denounce this vulgar positivist distortion but those voices, like that of Antonio Labriola, were stifled by official scholasticism or, as in the case of Korsch, they were condemned by the Communist International, funereal silence settling over their thought to culminate in their civil death. It was perhaps the Hegelian tradition preserved in Italy through the idealist Croce that made possible the appearance of a spirit as admirable as Antonio Gramsci who, during his years in prison, wrote pages that glowed amidst the philosophical baseness of Stalinism. And in his commentaries on Benedetto Croce he asserts, with reason, that the abstract concept of *homo oeconomicus* is, strictly speaking, a typical concept of the capitalist problematic, since it is precisely capitalism that engenders that abstract and reified character of man. In the field of esthetics, Gramsci was also the one who carried on the struggle against the work of Plekhanov who attained such prestige throughout the revolutionary world in my student days. Plekhanov never understood the sense of praxis, key to

all authentically Marxist philosophy and, therefore, never could go beyond the dualism of condition and subjectivity. He distinguished psychology, custom, feeling, and idea, on the one hand; on the other, economic conditions, which "explained" those feelings and ideas. Art, as well.

ASPECTS OF IRRATIONALISM
IN THE NOVEL

CRITICS WHO PROTRACT the rationalistic mentality of the past century inveigh against the unintelligible novels of our time. But, apart from the fact that the work of art has no reason to be intelligible (what does a Mozart symphony "mean?"), in the case of the novel it is irrelevant to ask for the intellectual order that pertains to logic and science. Irrationalism is, then, a specific attribute of the novel and an indispensable indicator of reality.

But variants must be distinguished. In Kafka, the judgements have syntactic rigor, there is coherence between subject and predicate. But that coherence does not go beyond the sentence, since there is no continuity of reasoning but the continuity or "logic" characteristic of dreams: intelligible determinism has been replaced by another that is mysterious or supernatural. In Joyce, irrationalism reaches as far as judgement itself since, at times, agreement between subject and predicate disappears: asyn-

tactic language succeeds logical language. Faulkner who wrote *The Sound and the Fury* directly under the influence of Joyce utilizéd that technique to attempt an absolute realism (far from practicing the unrealism supposed by the fans of photographic naturalism) since only through that technique is it possible to approximately describe an idiot's view of the world, of a being whose universe is a melange of odors, fleeting visions, and tastes — a chaotic and contingent universe.

EXISTENTIALIST PHILOSOPHY
AND POETRY

NOT ONLY WAS EXISTENTIALISM BORN in the romantic period but it was engendered for the same reasons, and even its language originates in poetry. Even today, after Husserl and his transcendence of Kirkegaard's radical subjectivism, the romantic lineage is evident in a thinker like Jaspers when he defends "nocturnal passion" as against "diurnal law" in maintaining that philosophy should renounce breadth for narrow profundity, or when referring to the coded language with which the existent seeks to call up its fellows from its craggy island. Nor is it by chance that death should have been the theme *par excellence* of existentialist philosophy, the romantic theme by antonomasia.

REDEMPTION OF THE BODY

MODERN TIMES were built upon science and there is no science but that of the general. But since exclusion of the particular is destruction of the concrete, modern times were built up through philosophical annihilation of the body. And if the Platonists excluded it for religious and metaphysical reasons, science did so for coldly gnoseological ones.

Among other catastrophes for man, this proscription exacerbated his loneliness. Because that gnoseological proscription of the emotions and passions, the sole acceptance of universal and objective reason, transformed man into thing, and things do not communicate — the nation with the most extensive electronic communications is also the one in which human beings are loneliest.

Language (of life, not mathematics), like the other living languages, (art, love, and friendship) is the ego's effort to reach out from its island to overcome its loneliness. And those attempts are possible from subject to

115

subject not via abstract symbols of science but through the concrete symbols of art, through myth and fantasy — concrete universals. And the dialectic of existence operates in such a way that the deeper we plumb our own subjectivity the closer we come to others.

We do not mean to say that modern times would have ignored the body, but that they lessened its cognitive capacity. They had expelled it from the realm of pure objectivity without noticing that in so doing they were reifying man himself since the body is the concrete support of his personality. This civilization, which is divisive, has separated everything from everything; the soul from the body as well. With terrible consequences. Consider love. The other's body is an object and as long as contact is made with the body alone there is nothing but a kind of onanism. Only through the relation of an integrated body and soul can the ego emerge from itself, transcending its loneliness and achieving communion. For that reason, pure sex is sad, since it leaves us in the initial loneliness with the aggravating circumstance of the disappointed attempt. And it explains how love, although one of the central themes of all literatures, has in our time taken on a tragic perspective and a metaphysical dimension it did not have before: it has nothing to do with the courtly love of the epoch of chivalry, nor the worldly love of the eighteenth

century.

The redemption of the body through existential philosophies meant a re-evaluation of the psychological and the literary beyond the merely conceptual. Only the novel, then, can integrally encompass pure thought, feelings and passions, dream and myth. In other words, an authentic anthropology (metaphysical and metalogical) can be achieved only by the novel, as long, of course, as we broaden the genre without the guilt feelings that arise from literary sophistries or mistaken servitude to the spirit of science.

The pre-eminence Nietzsche gave life has already been mentioned. The anthropocentric revolution of our time is synthesized in that election. That center will no longer be the object nor the transcendental subject but the concrete person, with a new awareness of the body that sustains it.

Nietzsche's vitalism culminates in existential phenomenology because it overcomes mere biologism without renouncing the concrete integrity of the human being. To Heidegger, in fact, to be a man is to be in the world and that is possible because of the body; it is the body that individualizes us, that gives us a view of the world from the "I and here." No longer the impartial and ubiquitous observer of science or objectivist literature, but the con-

crete I, incarnate in a body. In the body that transforms me into "a being for death." Thus, the metaphysical importance of the body.

This concreteness of the new philosophy was always characteristic of literature which never left off being anthropocentric although many of its theoreticians paradoxically wanted it to. This concreteness restored man's authentic tragic condition. Existence is tragic because of its radical duality, because of belonging at the same time to the realm of nature and to the realm of the spirit. As body, we are nature and, consequently, mortal and relative; as spirit, we share in the absolute and eternal. The soul drawn upwards by our anxiety for eternity and condemned to death by its incarnation seems to be the true representative of the human condition and the true seat of our unhappiness. We could be happy as animal or pure spirit, but not as human being.

Klage asserts, after Nietzsche in part, and correctly, that the spirit *(Geist),* the expression of the rational and transcendental in man, disturbs and even destroys the creative life of the soul *(Seele)* which is irreducible to the rational, to the impersonal and objective which is particular to the spirit. The soul is a force found in intimate connection with living nature, creator of symbols and myths, capable of interpreting enigmas that confront man and

which the spirit, can at most, only exorcize.

This destruction of the world of myth by the spirit through the mechanical action of concepts is depersonalization and death. The spirit judges while the soul lives. And the soul is man's only power capable of resolving the conflicts and antinomies that the spirit spreads like a net overflowing reality. Only symbols invented by the soul, not the dry concepts of science, make it possible to arrive at man's ultimate truth. Only the soul can express the flow of the living, the real-nonrational.

Thus, the gnoseological transcendency of the novel. For the novel is a product of soul, not pure spirit.

SOCRATES AND SARTRE

IN AN EARLIER ESSAY, I thought I had found a link
between Sartre and Socrates, a revealing link with respect
to their thought and sense of existence. Both were ugly,
hated the body, and sought a perfect, spiritual order. They
were disgusted by the soft and glutinous, the most crudely
human form of man, and the contingent, since it does not
even have the purity of mineral or crystal. Should it be
surprising that Platonic doctrine was Socrates' invention?
Artistic creations and those of thought are generally like
dreams — antagonistic acts. And Platonic thought could
not have been invented by a race of incorporeal archangels
but by passionate men like the Greeks and, in particular,
by an individual who, as a foreigner remarked upon meet-
ing him, "had all the vices written on his face." To that
philosopher, as the case twenty centuries later with Sartre,
incarnation was the fall, the original woe. And because
sight is the subtlest of the senses, the closest to pure spirit,
as much as for the perverse power it exercised over them,

both philosophers were to give philosophical pre-eminence to that sense. And so, after the time of that Greek enemy of the corporeal, philosophy was to become pure contemplation, disdainful of flesh and blood. And it was not until the advent of existentialism that those concrete human attributes became part of philosophical meditation, even in Sartre's contradictory form who, though consciously an existentialist, was psychoanalytically always a Platonist, a rationalist.

Marill-Alberes considered it revealing that Sartre had tried to prove some of his ideas through the figure of Beaudelaire, a personage who entranced him to the point of being the inspiration of two of his characters: Daniel and young Philippe. If we go through the poet's autobiographical writings, we find, apart from the intention of writing a metaphysical novel, other features that foreshadow Sartre: hatred of living nature, cult of infertility, obsession with a frozen or crystalline universe, pathological Platonism. Beaudelaire has the same passion for cleanliness as many other sinners of the flesh who feel guilt, the same diurnal hatred of the carnal that is the exact opposite of their nocturnal debility. And since woman is earthliness *par excellence,* the moist and dirty by association, Platonism appears always to be linked to a phobia against the feminine (in the same way that existentialism and, in general,

romanticism is the rebellion of the feminine elements of humanity). Like Beaudelaire himself, Roquentin feels disgust for the contingency of the organic world and longs for a pristine universe, the universe which, paradigmatically, is that of music and geometry. He yearns for the black who, in the midst of imperfection and ugliness, in a foul room in a tall New York building "saves himself" by creating a melody that will belong forever to the eternal and absolute orb. It seems to me as much food for thought that Pascal, Sartre's predecessor in his Jansenist outlook, a perhaps murky adolescent in search of purity, would encounter an Eden (transitory) in mathematics. The mature Pascal was to say later that we are galley slaves chained to the same slave ship, awaiting death. If hope in God were to be expunged from this idea, what remains seems quite like Sartre's thought. In summary, with the ugly person's sense of inferiority, Sartre grants the glance of others an almost supernatural power for petrifying and dominating us; because the world of things is the world of determinism and to reify a man is to deprive him of his freedom. The human being thus becomes an ambiguous and dramatic struggle between the determinacy of the physical universe and freedom of consciousness.

A number of consequences derive from this basic fact which demonstrate the ontological value of shame, mod-

esty, clothing, and dissemblance. I feel embarrassed be-
cause I am being observed and that is proof not only of
my own existence but of that of other beings like me.
Thus, living with others turns into a mortal struggle be-
tween equally free consciousnesses, each seeking to petrify
the adversary. On dressing, on dissembling, on donning
masks, we try to mislead the enemy. Slavery is at its highest
and most degrading point in the sexual act when the naked
body is exposed with utmost defenselessness and the word
"possession" takes on philosophical meaning beyond the
purely physical.

Emmanuel Mounier's interpretation of Sartre's psy-
chology approaches the one we are now making. They
perceive being intensely and suffer the universe's usurpa-
tion of them, a hostile, grim, threatening universe. Perhaps
this original weakness, this sensation of helplessness, leads
them to establish the value of compromise in the same
way that lack of an attribute can impel us towards a
profession that compensates (Demosthenes' speech de-
fect). This flight from the corral of matrimony and the
priesthood through dialectical pirouette or irony is already
insinuated in Kierkegaard. But in no one else is this im-
pression more evident than in Sartre for whom "the world
is superfluous" and threatens to swallow up the ego. Thus
the importance in his existential psychoanalysis of the

notion, physical and ontological at the same time, of the glutinous. In the glutinous, the other appears to cede at my touch, the better to oust me. In short, the universe of a paranoid.

Wouldn't the feeling of having frustrated what Marcel called "man's nuptial link to life" express this rage against being? Here Mounier accepts in good measure the criticism of Sartrian thought on the part of certain Marxists. There is much talk of compromise but on what basis? Nothingness? Absolute absurdity? I believe that it is precisely this contradiction between his profound and gloomy vision of *Nausea* and his Jansenist guilt feeling that turned him to social struggle; his political activism is a reaction of the will undermined by his ontology.

LOGIC AND THE GREEKS

THE BALANCED GREEK is an eighteenth-century invention that shares a place in the arsenal of stereotypes together with the phlegmatic Briton and the prudent Frenchman. The deadly and anguishing Greek tragedies would suffice to put an end to this nonsense had we not proofs of a more philosophical nature, such as the invention of Platonism, in particular. Each invokes what he does not himself possess. If Socrates invokes Reason, it is precisely because he needs it as a defense against the fearsome powers of his unconscious. And if Plato then instituted it as an instrument of Truth it is because he distrusts his own poetic emotions. We are imperfect, our body is fallible and mortal, our passions blind us. Why not aspire to knowledge that would be infallible and universal? Is this theorem we are demonstrating not valid for all, and in any language? Is it not indifferent to rage or pity, sympathy or passion? Here, then, is the secret road to eternity. Mathematics gives us the key and shows us the way to the other world.

Repudiation of art was then inevitable (as it comes to be again, in a certain way, in the Sartrian position), repudiation which, as Plato himself suggests in criticizing Homer, is not so much moral as metaphysical. In the first dialogues he still speaks well of poets, but in the last ones, he berates them as much as the Sophists, as traffickers in Non-being, technicians of the lie and illusion. And it is to be expected if what he said in the *Republic* is kept in mind: God created the prototype of the table, the carpenter makes a copy of that prototype, and the painter makes a copy of the copy — an attenuation to the cubic power. (Which, incidentally, provides us the best criticism of imitative or "realistic" art.) Artists, then, should be condemned in the name of Truth as philosophical counterfeiters.

In summary, Socrates invented Reason because he was foolish and Plato repudiated art because he was a poet. Some record for these fomentors of the Principle of Contradiction! Which simply goes to prove that Logic doesn't work even for its inventors.

PURE IDEAS AND INCARNATE IDEAS

TOLSTOY AT HIS MOST AUTHENTIC is not the moralizer of his essay on art but the tortuous and bedeviled Tolstoy we sense in the *Memoirs of a Madman.* The pure thought of a writer is his strictly diurnal side, while his fictions also share in the world of his monstrous shadows. The soul, between flesh and spirit, ambiguous and anguished, swept along frequently by upheavals of the body and aspiring to the eternity of the pure spirit, always hesitating between the relative and the absolute, is the realm of fiction by antonomasia. There are the same differences between soul and pure spirit as between life and the sacrifice of life, as between sin and virtue; as between the diabolic and the divine. And it is the abyss that separates the novelist from the philosopher.

Which does not mean that ideas cannot or should not appear in fiction, since the human beings in whom they come to life, like the ones of flesh and blood, cannot but think and, as they weep, laugh, or are moved, they

reflect and argue at the same time. However, the ideas that arise in that way are not the pure ideas of formal thought but the impure mental manifestations of the existent. Those characters do not talk of philosophy but live it. And the difference between a genuine character in a novel and a puppet that merely repeats pure thoughts is the same as that between the man Immanuel Kant (with his ailments and vices, his precarious health, his feelings) and the ideas of the *Critique of Pure Reason*.

Furthermore, it should not be assumed that because of being fictional characters, because of the very fact of existing on paper and having been created by an artist, the characters are not free and, consequently, can hold only ideas previously conceived by the author. Not necessarily, in any case. Emerging, as they do, from the integral persona of their creator, it is natural that some of them should manifest ideas that in one way or another, perfectly or imperfectly, have at some time arisen from the mind of the artist himself. But even in those cases, such ideas, on being incarnated in characters that are not exactly the author's creations, on appearing blended into other circumstances, other flesh, other passions, other excesses, are now no longer the ones the author could have once expressed from his own viewpoint; and distorted by the new pressures (pressures that in fiction are usually tremendous

and devilish) take on a glow they did not previously possess, acquire new angles or facets, achieve an unusual power of penetration. In short, they are different ideas. Besides, real beings are free and if fictional characters are not free they are not true, and the novel becomes a valueless simulacrum. An artist feels towards a character of his like an ineffectual spectator before a flesh and blood being; he is able to see, even *to foresee,* the action, but unable to avoid it (which, incidentally, reveals up to what point a man may be free without that freedom being contradictory to God's omniscience). Something irresistible emanates from the depths of another being, from his very freedom, that neither the spectator nor the author can impede. The peculiar thing — what is ontologically surprising — is that the creature is an extension of the artist; and everything happens as though one part of his being were schizophrenically the witness of the other part, of what the other part does or prepares to do; and an impotent witness.

Thus, if life is freedom within a situation, the life of a novel character is doubly free since the author is enabled to mysteriously try out other fates. It is at the same time an attempt to escape the inevitable limitation of our possibilities, an evasion of the quotidian. The difference, for example, between the paranoid created by an artist and a

flesh and blood paranoid is that the writer who creates him can recover from the madness while the madman remains in the asylum. It is naive to think, as some readers do, that Dostoyevsky is a character by Dostoyevsky. Of course, much of him resides in Ivan, Dmitri, Alyosha, Smerdyakov, but Alyosha would have been hard put to write *The Brothers Karamazov.* Nor should it be assumed that Dmitri Karamazov's ideas are strictly Dostoyevsky's. In any case, they are some of the ideas that were taking form in his creator's mind in the delirium of sleep, in half-sleep, or in ecstasy or epilepsy, combined with other contrary ideas, tinged with guilt feelings or rancorousness, linked to suicidal or homicidal compulsions.

By virtue of the existential dialectic that unfolds from the writer's soul incarnating in characters in violent struggle with one another and, at times even within themselves, there unfolds another profound difference between the novel and philosophy. Since, while a system of thought must be constructed in coherent form and with no contradiction, the novelist's thought emerges in tortuous, contradictory, and ambiguous form. What, rigorously speaking, is Cervantes's concept of the world? That which emanates from Don Quixote or the one Sancho blabbers? What are the ideas truly professed by Cervantes regarding government, love, friendship, power, gluttony? We may be

sure about some of them, and that he sometimes thought like the materialistic and skeptical shield bearer and sometimes let himself be carried away by the wild idealism of his madman when he was not possessed by the two systems of thought simultaneously in a wrenching and melancholy struggle within his own heart, that heart of great creators who seem to sum up the evils and virtues of all humanity, the grandeur and wretchedness of man, in general.

All in all, in spite of this multivalency of its characters, on finishing a great novel we feel a *sensation* of having participated in a distinctive vision of the world and of existence that arises not so much from random ideas alternately expressed by the characters but from a certain overall atmosphere, a certain tonality that seems to tinge the objects and figures of a novelistic universe like Kafka's (for the obvious reason that almost no characters exist there, but just that atmosphere) and likewise obtains in novels as peopled and diverse as *The Brothers Karamazov* or *Light in August.* Perhaps it should be admitted, along with Moravia, that this "ideology" of the novelist is always to be found in allusion and presentiment, through a procedure that would seem to consist of creating an exact metaphysics and, then, in subducting its ideological part, leaving only the factual part. At least, that is the impression given by a Kafka.

MEN AND WOMAN

K ARL M ANNHEIM SHOWED that social life is dominated by ideological fantasies that are accepted as objective truths. This is the case of "ideas" regarding womankind. The great changes in woman's position, her increasingly active participation in almost all phases of community work, show how large a part plain prejudice or stubborn masculine arrogance played in most of the "ideas" in which woman's inferiority was implicit.

But through a curious dialectic of the process and as a consequence of the same masculinizing mentality, the opposite phantasy was propagated that woman is *identical* to man.

The celebrated French aphorism, set forth as a jubilant exclamation, reminds us — has to be constantly reminding us, in view of how things are going — that a certain difference exists between the sexes. In opposition to this propaganda, it can be argued that the human being is not mere biology but a cultural being. But it should be

responded that the highly complex transformations that successive cultures have carried out upon that infrastructure have not annihilated it; children continue to be brought forth in the familiar way. This simple verification of discrepancies immediately turns on the radar system the female of the species has along its borders and which is triggered the moment even a fly enters enemy territory. This alarm is unfounded in my case; I am not speaking of *superiorities* but merely referring to uncontentious and ostensible *differences*. We will soon see what kind of spiritual consequences these basic biological differences can give rise to. Meanwhile, and to reassure, I hasten to recall that on more than one occasion I found it necessary to remind a certain type of disdainful macho of such women as Emily Bronte, Sonya Kowaleska, Edith Stein, Simone Weil, and Virginia Woolf.

A society like ours created, implemented, and judged by men reveals its contempt not in its theories but (half-consciously) in its language.

If it is kept in mind that the left is linked to the unconscious and to the feminine (Cf., the theories of Jung, for example), it is significant that everything deprecatory in our culture turns out to refer to the left hand. Not only in Spanish does the word for "right" have to do with justness and correctness. That is the case in all the Indo-

European languages which originated in patriarchal communities going back to the Aryans: *orthos, rectum, regere, regimen, rectitudo, regula, dirigere, corrigere, erigere, derecho. . . .* To say nothing of more commonplace customs and habits: the right side of a fabric is the one to be displayed, the left side to be hidden; left (sinister) is always related to misfortune, perversity, ominousness. One swears with the right hand, the sign of the horns is made with the left, and so forth. That this is characteristic of patriarchal communities appears quite evident when one examines matriarchates, in which the left is the good, not the days but the nights are counted, Tibetan prayer mills turn counterclockwise, etc. Laws are established and good is determined by those who rule. Hardly news, of course.

However, Modern Times aggravated the oppression of women because technical and abstract society evolved out of patriarchal society, carrying the predominance of the male mentality to catastrophic consequences.

To accept life is to accept the existence of Evil. Romanticism as a philosophy of life could not ignore it as an unavoidable and positive manifestation of concrete

being. William Blake, who in many ways anticipated Nietzsche and Jung, thought that man would reach his loftiest expression when he succeeded in integrating his heaven and his hell.

Science and pure thought were torpidly incapable of accepting what art never ceased to consider basic since art is practiced in the very first place thanks to commerce with the all-powerful "inferiors," the forces emanating from the earth and the unconscious, the sempiternal creators of magic and myth. Let us come out with it once and for all: the feminine forces.

This abstract civilization has tragically divided man. To abstract means to separate, and everything in this mechanical culture has been separated from everything, body from soul, intuition from concept, man from cosmos. In this vast and monstrous process of disintegration, art is the only thing that has remained faithful to primitive unity. More or less repressed, according to Jung, we bear the opposite sex in our unconscious. If we admit that the irrational is our feminine part, art would be the expression of femininity modified by masculine consciousness and would constitute perhaps the *only* integrating manifestation of man in this abstract universe. The ideal we have lost is that which the Chinese symbolize in the Tai-Gi-Tu, whose two parts make up the balanced whole, having the same

form and exterior, complement and need each other: the masculine and the feminine. The spirit is inspired and self-fecundated with the reciprocal action of the two sexes, and there is no birth without this collaboration. Not only physical but spiritual birth as well. The gross scientism mentality oversteems rational thought but today we know that no knowledge arises from reasoning. Reason only develops what is already a germ in ultimate intuitions.

It is time for our redemption of magical thought to occupy a place side by side with logical thought which we must recognize as being unable to exist without it.

The surmounting of our crisis must thus assume a return to the magical and the feminine. The re-evaluation of myth, the redemption of the so-called primitive cultures, the recognition of the alogical elements are all indices of the form in which this crisis must be surmounted, the greatest, profoundest, and most dangerous crisis the human race has ever had to face.

That is, if the generals of the United States and the Soviet Union (known to be machos, all), with typical male mentality, do not press a button that will trigger nuclear war.

I can visualize a chart of the contemporary crisis and the possibility of overcoming it in this form: Medieval community (WE) — Renaissance Mercantile Individualism

(I) — Science and Capitalism (IT) — Concrete and Feminine Romantic and Existentialist Rebellion (I) — Phenomenological Synthesis, Towards a New Female-Male Community (WE).

Because of reflections of mine on sex and the occult powers — and without regard for my defense of social justice — I have earned a reputation as a reactionary among spirits who left the temples during the past century to kneel before a voltaic cell. Now, they kneel before a cyclotron, which makes their positivism more spectacular but no less ingenuous. As poverty-stricken as the predecessor but much less defensible because of the demolishing arguments applied to it by subsequent philosophy. And so, between a neighborhood progressive who founded a library called *"Light and Progress"* around 1900 and these transistorized ones who believe that all physical and metaphysical ills must be cured with computers, there is no difference of essence but of quantity: those of today are more myopic.

May women not permit themselves to be subjugated by this kind of electromagnetic pap! Let them realize that if humanity is to be saved it will not be thanks to the development of Japanese electronics but by a return to the Mother Earth we are forgetting and of which they are the true manifestation!

RECLAMATION OF THE
MAGICAL WORLD

ART, LIKE DREAM, invades the archaic terrains of the human race and, therefore, can be and is being the instrument for recovering the lost integration of which reality and fantasy, science and magic, poetry and pure thought form an inseparable part. And it is not casual that the countries most given to abstract reason are the ones where the artists have gone in search of the lost paradise: the art of children, or Blacks, or Polynesians has still not been triturated by technology-worshiping civilization.

REDEMPTION OF MYTH

W HEN MAN WAS STILL INTEGRAL and not a pathetic heap of dismembered parts, poetry and thought were a single manifestation of his spirit. As Jaspers says, from the magic of ritual words to the representation of human destinies, from invocations of the gods to prayers, philosophy totally impregnated all the human being's expressions. And the first philosophy, the primordial investigation of the cosmos, that dawn of knowledge revealed in the pre-Socratics, was nothing but a beautiful and profound manifestation of poetic activity.

The romantic rebellion was a reapproach to myth. The protoromantic genius of Vico already saw clearly what other thinkers did not come to understand until a long time after. And it was in good measure by dint of his thought that the re-evaluation was initiated which Freud and Jung were to bring to culmination in our day with the paradoxical cooperation of Levy-Bruhl (for, as the work of this ethnologist evolved, the vainness of any attempt at

total rationalization of man was verified). Having begun by demonstrating the passage from "primitive" mentality to "positive" consciousness, he was to conclude several decades later with a dramatic confession of defeat when he finally had to admit that there was no "primitive" or "prelogical" mentality as an inferior status of man, but a coexistence on two planes in any epoch or culture. We observe that the same "positive" mentality (I cannot help finding this adjective extremely amusing) is also one that inculcated into the West the idea that our technical culture is superior to the others and, for the same reasons and motivations, the idea that man's spirit, because of his greater propensity to logic, is superior to woman's spirit.

To enlightened thinking, man progressed to the degree in which he distanced himself from the mythopoetic state. Thomas Love Peacock said so in 1820 in a grotesquely enlightened way: a poet in our time is a semi-barbarian in a civilized community. Levy-Bruhl's excavation showed just how mistaken this claim was in addition to being outlandish and arrogant. Driven out of pure thought, myth took refuge in literature, thereby bringing about its profanation but, at the same time, its redemption. On a dialectically higher plane inasmuch as rational thought was allowed in alongside magical thought.

DEMYTHIFICATION AND DEMYSTIFICATION

FREUD WAS A POWERFUL but Janus-faced genius, since he possessed the intuition of the unconscious, which made him a member of the romantic family, coupled with the positivist medical training of his time. Thus, he tended to reduce any cultural phenomenon to scientific knowledge, a little like what happened with the Marxists. In his Dialectics of the Concrete, a fine thinker like Kosik called this: "The ability to transcend the situation in which the possibility of moving from opinion to science, from *doxa* to *episteme,* from myth to truth, etc., is based." This shows how even in a top-level Marxist there is a residue of enlightened thinking that values "light" over "darkness," and which relegates myth to the realm of mistakenness or backwardness. It is doubly curious that the same philosopher who grants absolute value to art does not consider that myth like dream belongs to the same universe as art and offers the same characteristics of "concrete totality"

Ernesto Sábato

which for Marxism, as for existentialism, is the form of the absolute. Vico already recognized the family relationship of myth and poetry and it is evident that the artist's spirit remains mythopoetic. Myth is not theoretical and one must agree with Cassirer in challenging all the categories of rational thought. His "logic" is incommensurate with our concept of scientific truth. But rationalist philosophy, never admitting such bifurcation, has always been convinced that the creations of mythopoetic function *must have intelligible meaning.* And since myth hides this behind all sorts of fantastic images and symbols, philosophy's task must be to reveal it. That is when the word demythification identifies with demystification.

I, on the contrary, believe that though myth, art and dream touch the bottom of certain permanent aspects of their condition, elements which if not metahistorical are, at least, parahistorical. They are alongside the socioeconomic process, referring to problems of the kind that perdure throughout epochs and cultures and constitute their only expression, sowing uneasiness or terror. An expression irreducible to any other and, particularly, Descartes' clear and simple reasons.

EVIL AND LITERATURE

THE DEVIL BEING the lord of the earth, the dilemma of good and evil is that of the body and the spirit. Rationalism was incapable of resolving the dilemma and simply obliterated it by suppressing one of its terms. With perversely dramatic results since the dark forces are invincible, and if repressed on one side, they reappear on another with the resentment of the persecuted. Rameau's Nephew seemed to be the most meaningful example since that character is none other than the Mr. Hyde of the progressive Diderot. The demonic and picturesque individual who dwelt in the cellars of correct scientism rebels in those pages with the violent authenticity always characteristic of the insurgency of those who stir up the subsoil of being. With the same right as Flaubert (but also the same unnecessary ingenuousness) Diderot could have confessed: "I am Rameau's nephew." This novel is thus one of the most curious manifestations of the existential dialectic between light and darkness. And the almost didactic contrast be-

tween progressive thinker and possessed man was not to recur in such an extreme manner until the advent of another French philosopher, Jean Paul Sartre. In the realm of the soul nothing is casual and if the greatest collection of the possessed appeared in traditionally Cartesian France, from Gilles de Rais to Rimbaud, the Marquis de Sade to Jean Genet, it is not in spite of that rationalist propensity but because of it. The forces of darkness are invincible, and if proscribed, in the way Illuminism tried to, they turn restive and burst out perversely instead of contributing to man's health, as always happens in the cultures of so-called primitive peoples.

First Goethe and then Marx, among many, admired this unusual novel, although surely the admiration we profess today does not have the same basis. That is not important. On the contrary, one of the characteristics of great works of fiction is that they are ambiguous and multivalent, admitting diverse and even contradictory interpretations. It is legitimate to praise their satire of bourgeois society; but, as invariably happens with creators of genius, the ghosts and enigmas of a more profound drama are made evident through the social problematic: those of the human condition, the questions — generally pessimistic — concerning the meaning of existence. It is in this that Diderot's work anticipated the literature of our day.

The central task of today's novel is the study of man which is equivalent to saying that it is the study of evil. Real man has existed since the fall. Without the Devil he does not exist. God is not enough.

Literature cannot lay claim to being the full truth about this creature, then, without a census of hell. Blake said that Milton, like all poets, belonged to the band of devils without his knowing it. Commenting on this idea, Georges Bataille maintains that the religion of poetry cannot be more powerful than the Devil, who is the pure essence of poetry; even though he would like to, he is unable to build and is only real when he is in rebellion. Sin and damnation inspired Milton, from whom paradise withheld creative power. Blake's poetry paled when distanced from the impossible. And any of Dante's except the *Inferno* is a bore.

Perhaps the drama of the poet in social revolution, in the building of a new society, resides in this tragic situation.

THE INVINCIBLE FURIES

WILLIAM BARRETT describes how in *The Eumenides* Orestes kills his mother on orders from Apollo, the deity that Illuminism was to launch upon the world. The conflict broke out between this luminous god and the Furies, the ancient matriarchal earth goddesses. The tragedy records the time in Greek history when those female deities had to give way to the new gods of Olympus. But ordinary men still remembered and unconsciously feared those nocturnal goddesses, and were filled with anguish at the choice imposed upon them. This anguish was linked to the development of Greek consciousness, which in a way is the modern consciousness, to the degree in which it advances along the road of civilization. But the verb "to advance" is already an obscure sophism in this arrogant culture that considers what serves its ends as good and positive and what does not as bad or false. Today, we can measure the huge tribute that modern consciousness has to pay for this proscription of the archaic powers of the unconscious. In

Aeschylus's play, a kind of compromise was made through the intervention of the ambiguous goddess Athena, that feminist. The Furies, disconsolate, threatened earth with all kinds of calamities. Athena recognized or should have recognized — wisdom of the poet — that they were more ancient and wiser than she. There can scarcely be any doubt: the reserve of the artist vis-à-vis science appears for the first time in Aeschylus. In the depths of her soul she senses that they should be revered and that although they represent the dark side of existence, without them the human being cannot be what he should.

The result of that rash proscription is before our own eyes. In the best of cases, as a violent but healthy and justifiable rebellion by oppressed forces and sectors: blacks and youth in the United States, women all over the world, adolescents, artists. In the worst of cases, neurosis and anxiety, psychosomatic illness, collective hysteria, violence and drugs. The series of sadistic sexual crimes committed by the Manson clan took place in the most technically advanced nation of the planet (perhaps the only place it could happen).

As for the Orient, the human being was protected until not long ago by the great mystical and religious traditions that insured man's harmony with the cosmos. The brutal and unbridled invasion of Western technology

has wrought damage already noticeable in Japan; the suicide of artists and writers is revealing. They considered themselves clever to be replacing age-old traditions with mass production of electronic devices.

ON CERTAIN DANGERS OF STRUCTURALISM

AS A PROFESSOR once solemnly asserted: With the sole exception of what is amorphous, everything has a structure. This pompous tautology aside, there is, in fact, almost nothing that cannot be considered a structure, from a cephalopod to *The Matthew Passion.* It is also clear that in such objects it is impossible to speak of one element if it is not in relation to the whole, as Aristotle had already pointed out in saying that "the whole precedes the parts." It was in this sense an indispensable reaction against atomism that had been so disastrously propagated in physics and wherever else. Suffice it to consider the insanity of medical specialization. How can there be such a thing as cardiologists? An investor can get a heart attack if the market drops: what's needed are universologists. Also healthy, as long as not carried to an extreme, was the reaction against the explanation of positivism, those wonders of Taine.

As usual, the worst damage to a theory is inflicted by its dogmatists who caricaturize and fossilize it. To be sure, the characteristic of the new movements is absolute truth. Until they are no longer new. Every philosophical system seeks to shut down argument over subject and object until it becomes a chapter in the history of philosophy. The main error of the extremists of this movement is precisely the attempt to abolish history, which seems to me a bit exaggerated when we look at how it all came to pass. Synchronism is brandished like a club and he who mumbles an ancient litany gets his head cracked. To be sure, we now know that it was a good reaction against the atomists, positivists, and dogmatists of history. But, they went too far. Consider language. It is a reality in constant change like all cultural reality. And sooner or later — oh, the diachronism of ideas! — it is necessary to accept the modest but devastating fact of the transformation of structures even as a succession of diachronic states. It has to be admitted that a germ of change that will lead to a new structure is present at every stage of a language. Well, keep cool, it is not so dishonorable!

In short, structuralism is valid to the point at which it ceases to be so. Which is considerable. Dangers set in beyond that point. First, nonrecognition of the importance of history. Second, the strengthening of an operationalist

and even cybernetic conception of the spirit, thereby contributing to the worsening of the alienation provoked in man by the technology of our time. Certain rigorously valid analyses for mathematical entities are *relatively* valid for man. This extreme type of structuralism — as Lefebvre observes quite justly in his notable work — runs the risk of hypostatizing, of giving real value to mere conceptual abstractions. Of course, these extremes were to be found particularly in the United States, in keeping with its usual scientific fetishism, in the same way that the most absurd extremes of logical positivism were produced. As for certain representatives of the new criticism, by reacting against those positivist "explanations" of the work of art by things like climate and similar determinisms, they committed the inverse error of an immanentism which all at once seemed to transform a novel into a Platonic object, outside of time and space, removed from the vicissitudes of man and society. And outstanding studies, like those in *Mimesis,* by Auerbach, in which Julien Sorel is inconceivable except under the social, political, and even economic conditions of the Restoration, were invalidated at one fell swoop. I know that not all structuralists are guilty of such absurdity, but it is true that their most fevered dogmatists were. Besides, their operationistic tendency led — and still leads — them into excesses, towards a kind of *ars combinatoria,*

with a methodology that is very familiar to those of us who have practiced mathematics at some point: permutations and transformations, topological algebra, and games theory. Excellent methodology and perhaps the only valid one for entities of the mathematical universe but inadequate for man.

Then, finally, the overestimation of language to the point, in the most outlandish cases, of eliminating any referential function, leaving nothing but a kind of discursive self-contemplation. The risk being run is that of severing all links with life. Not for an instant am I supporting the foolishness of granting "substance" pre-eminence over "form." On the contrary, I believe that in all great art the two terms are inseparable since substance appears ineluctably formed and the form is ineluctably content. If substance were decisive, it would be impossible to understand how Shakespeare could have built a great play upon a trivial plot of his time. It is precisely this principle that makes me quarantine a literature that gives pre-eminence to form. In the same way, but for an opposite reason, I put myself on guard against those famous "literatures of content" such as socialist realism and other edifying trash.

The point of departure of existentialism and Marxism is concrete man (the only kind that actually exists) which is tantamount to saying that they stem from subjectivity.

Furthermore, this conception gives true dignity to man since it is the only one that does not consider him an object. On the contrary, the very materialists themselves consider man a *consequence,* the resultant of a group of determinations, as if he were an atom or a projectile, entities governed by blind causality alone. But subjectivity is not rigorous and definitively individual inasmuch as man discovers not only himself but others in the *cogito.* Contrary to Cartesian and Kantian thought, both existentialism and Marxism consider that man finds himself in the Other. The discovery of one's intimacy is the discovery of the other intimacy, of the person who coexists, suffers and talks with one, communes with one through language, gesture, hate or love, art, or religious feelings. This inter-subjectivity, this web between subjects who make up human existence, operates at every moment through *praxis* which is the reality of man and his history. There is no such chasm, then, between subject and object. And those materialists who overestimate object to the point of considering it *the* reality, are as mistaken as those who think that reality is only that of the subject. In Hegel man is already an historical being who keeps making himself, achieving the universal through the individual. Let us turn to Shakespeare again. What "reality" is revealed in his plays? A purely external reality? There is a type of Econ-

omist who sees in his plays "nothing but" the artistic representation of primitive capital accumulation. That conception assumed that this truth can be attained by another path, through sociology, let us say, but that in the case of Shakespeare it is presented "artistically." The same substance in different form. Which is nonsense. Art is a language in itself and creative, creating *other* realities, and expressing them in a manner irreducible to other language. There are those who wish to see dreams explained with clear and definite reasons, instead of the obscure symbols in which they are manifested. But, strictly speaking, dream expresses a reality in the only form it can be done. But, what is more, that expression is its reality. The same happens with a symphony or novel. What did Kafka mean in *The Trial?* What is in his book. Art, like dream and myth, is a replica of reality and no more. Yet, in any case, *it is a revelation of something* and not an end in itself. Which does not mean that it is the expression or mechanical revelation, the mere reflection of an objective reality. This idea of reflection is one of the commonplaces of vulgar materialism and positivism. Mme. de Staël went as far as to speak of a "republican art" in the same way that Stalinists under orders from Colonel General Zhdanov spoke to us of "bourgeois art." There is obviously a relation between art and society and perhaps it is even possible to

speak of a homology. In a society like that of today, for example, in which man is anguished by reification, nostalgia for lost individuality, enslaved intimacy, and in which violated ego is more intense, how not to anticipate a burgeoning of lyrical expression? But this attitude is not a reflection but an act of rebellion and negation, a creative act with which man enriches pre-existing reality. Man makes man, said Marx in a phrase as remote from the familiar reflection as a kick from a mirror. And in that, as in so many other manifestations of current thought, tribute must be paid to omnipotent Hegel and his idea of man's self-creation. And this man who makes himself does so by means of everything the subjective spirit is capable of making, from a machine to a poem. Any work of art, and language, too, displays a two-sided and dialectical character. It is at the same time an expression of reality and a reality in itself. A reality that does not exist outside of that work nor prior to it. Language thus becomes an instrumentation and an end in itself.

Reflectologists consider language a copy of the external world and believe the linkage of verbal signs would reproduce the linkage of events, thus reducing subjectivity to the role of mirror. At the other pole, I believe that certain extreme structuralists commit the opposite error: language in and for itself. It was legitimate and advanta-

geous to methodologically place meaning in parentheses in order to study language as a system, immanently. But forgetting that this attitude was — or should have been — provisional was damaging. Finally forgetting meanings and the human process that always ends up by breaking the systems from outside.

I believe that there is some link between that extreme doctrine and the overestimation of language in some of the writers of our time.

In fact, there are writers and theoreticians today for whom a literature not based on a revolution of the word has no meaning. But everything depends on the scope given that assertion.

Capablanca revitalized the game of chess using the customary pieces. With stones identical to those that served to build romanesque basilicas, the new culture constructed Gothic cathedrals. Which goes to prove the primacy of structure over elements which in language would be the words themselves.

But one must beware of the fallacies in play and, in particular, of those that give rise to the qualifying adjective "new," which gives rise to the most equivocal semantemes. Because a work like *The Trial* must be taken *in its totality* as a new language, not in consideration of novel words nor syntactical or morphological departures. Schleier-

macher, that theologist of German romanticism, had already put consideration of the whole first. It is, therefore, illusory to speak of revolution when it only takes place with the violation of vocabulary or even syntax unless given status by the entire semantic field, by the stylistic aura of the total creation, as in Joyce.

This is not to say that it is impossible to reinvigorate literature through technique; I deny that it is the *only way,* as some extremists maintain. Kafka showed that it is not necessary. And the many deficient heirs of Joyce show that neither is it sufficient. Certain rhetoricians of this ilk should have pointed out to them Kafka's genial capacity for giving new value to the humblest of words, the infinity of theological and philosophical echoes he extracts from a courtroom cliché like "trial." Yes, indeed, he is in that sense a great revitalizer of language. But isn't any literary genius? After Proust, the word "love" no longer had the same meaning.

ON METAPHOR

TO ARISTOTLE, metaphor was the most important of the literary jewels that adorn style. The first to call attention to such an error was Gianbattista Vico who asserted that poetry and language are essentially identical and that metaphor, far from being a "literary" resource, is the principal structure of all languages (Cf. *Sciencia Nuova*). At the beginning, it consisted of dumb action or body gestures in some way related to the ideas or feelings seeking expression. Hieroglyphics, coats of arms, and emblems are nothing but metaphors. And even the word figure is itself already a figure. It is impossible to speak or write without metaphors and when it seems that we are not doing so it is because familiarity has made them invisible.

KARL VOSSLER FORGOTTEN

Is NOT SUCH FORGETFULNESS or scorn due to the advancement of scientific mentality and consequent predominance of the abstract over the concrete, of the general over the particular? Now very few are concerned about flesh and blood man except for artists, the police, and some thinkers looked down upon by scientists. Apparently, the reification of the human being is not a misfortune which, at most, would have to be accepted as inevitable, but a step forward that should make us jump for joy. This same euphoria began to dominate in language theory, culminating in a depersonalizing and deterministic neopositivism. Vossler, on the contrary, invoked the spirit as von Humboldt did in the past century, identifying himself thus with those who like Kierkegaard defended concrete man against the System. For that reason alone we should redeem Vossler as a thinker of the future, if the future is not to be a collection of anthropoids operated and programmed by computers.

It is true that neither did Saussure consider language a bipolar activity between the concrete individual and society, between man's freedom and the determinism of things, between style and grammar, between *"parole"* and *"langue."* But while Vossler saw the creative individualistic side as positive, Saussure rejected it as an obstacle to systematization, the systematization to which all science is subject. Does it not give pause that the seed should already have been present in him of what certain structuralist extremists later carried to its ultimate consequences? Not only in the United States where traditionally there has been a leaning toward all sorts of positivism, but in most places to some extent, as is demonstrated by a work entitled *Mathematik und Dichtung,* published in Munich with the allusive subtitle "Problems of an Exact Science of Literature." Which is more or less the equivalent of establishing an exact science of dreams and nightmares.

These doctrines manifest and aggravate at the same time the alienation of man. Forgetting that analyses suitable for polyhedrons, sinusoids, and matrices are not applicable to an animal so contradictory that he is capable even of inventing systems that deny it.

Reiterating von Humboldt's thesis, Vossler maintains that language is live energy, an energy that always ends in breaking down grammatical categories. Which is not a

calamity, as the inspectors of linguistic morality think, but one of the advantages of life over death. In one of his studies he points out the charm of ignorance of the rules in children and irreverents the like of Benvenuto Cellini. Some pedant to whom he modestly gave his *Vita* to read must have told him that it was badly written and that a professor should correct it for him. For this reason, perhaps, he went to Benedetto Varchi who was wise enough to understand that he should not touch a single line and that everything *outré* was what gave it charm and expressiveness.

Of course, the goldsmith did not set out to capitalize on naïveté, Nor did the *douanier*, as happens with so many pseudo-primitives who stalk the galleries possessed of technical skill and academicism. A good part of Rousseau's expressiveness is due precisely to his authentic ingenuousness, to that "character" that is frequently ruined by rigorously grammatical painting. Creators, whether naïfs or not, do things that cannot or should not be done — that are not acceptable (in the name of the community, the System, good manners, or good grades). To be sure, once done by great creators, they turn into prestigious models, in the same way that the adventurers of a victorious putsch become venerable patriots. And so, a new academy comes into being and then the "school" spawned by an irrespon-

sible genius ends up as a new mannerism.

To summarize, in order for linguistic art to prosper a certain tension must exist between grammatical categories and psychological flights. So Vossler asserts and I am glad to assent. Only in mathematics can that perfect concordance be attained between what is thought and what is said inasmuch as ideal entities are univocal, eternal, and, therefore, invariable: centaurs neither get fat nor die. It is appropriate at this point to recall Descartes and his project for a mathematical language. Giambattista Vico, on the other hand, would have to be placed at the opposite pole among Vossler's forebears since he perceived the vital principal of language as residing in poetic fantasy. To the German philologist, living language is an uneasy mediator between individual and community, and thanks to its hesitancies and maladjustments, it remains in unstable equilibrium, in the rich mobility known as evolution.

ON ABSTRACT ART

A CERTAIN FORCEFUL SCHEMATISM constitutes the power — at the same time the precariousness — of Marx, Freud, and, in general, all founders of schools and isms. They are all in a way men of action in the sphere of thought, beings who, blessed with great intuition for the elemental, do not suffer infinite doubt over nuances as other thinkers do. If these characteristics make the latter more sensitive in perceiving the subtleties of reality, they are, on the other hand, rendered incapable of recording the broad lines of force, like the oversensitive seismographs — suitable for almost imperceptible tremors — that are made to jump and become unhinged by great earthquakes without their being able to record them. These nuancers of ideas are the ones who then enrich with arabesques and shading the somewhat brutal formulations of those pioneers of analysis to the point where the great and vigorous lines become so attenuated, broken, and blurred that the work of a new schematic spirit is called for to breathe life

into the ideological design; in the same way and for analogous psychological reasons the somewhat rough constructivism of Cézanne had to follow the final disintegration of the impressionists.

I do not consider it unfair to place Wilhelm Worringer in that category of schematic spirits. His ideas shook up twentieth-century esthetics and reformulated the problem of the plastic arts in an intense and instructive light. His major defects, in my judgement, were two. First, that he places all the manifestations of abstract art in one bag, trying to explain them always through his central hypothesis; second, that he judges problems rectilinearily that are dialectical and zigzagging.

It is unnecessary to present Worringer's main theses *in extenso.* Suffice it to recall that for him there were two opposing arts — abstraction and naturalism — not for reasons of greater or lesser technical skill nor because of higher or lower esthetic capacity, but as a consequence of different spiritual needs. While naturalistic art is the result of a happy concordance of man and the world, as in the great age of Pericles, the tendency toward abstraction is found in civilizations whose spiritual attitude is completely the opposite and in which a sense of separateness prevails, of discordance, of disharmony between the human being and nature, as was the case among the Egyptians.

Worringer's ideas cast a strong light upon the artistic expressions of peoples and civilizations that had been judged with a combination of naiveté and arrogance to be preparatory and defective stages of great naturalistic European art. But it is fair to accuse Worringer of being heavily schematic.

Mere consideration of the spirit of the Greek world gives us to understand how careful we must be in accepting Worringer's theses. Forces of the spirit never act unidirectionally but manifest, or are darkly acted upon, by antagonistic forces, as a consequence of which the surface of a culture is always disturbed. And even when it seems calm or scarcely ruffled — as in the great age of Pericles — deep currents create what might be called the ground swell of a civilization. Thus, at the time Greek culture seems to be at its peak in the spirit of Olympian serenity, at the time when — according to the accredited clichés — equilibrium, grace, measure, and proportion held sway, at the very moment in which, as never before in history, man and the world seemed profoundly reconciled, in that very same exemplary instant of the culture, despite the external manifestations (and, strictly speaking, for the same reasons), tremendous forces stirred up the depths of the Greek soul. And so while Socrates counseled — *et pour cause* — the proscription of the body and its passions, Euripides was

unleashing the fury of his bacchantes on the stage in Athens.

How to conciliate this dramatic dualism of the Greek soul and the famous Olympian serenity of the Pantheon of Commonplaces? And to what point is it possible to believe in that harmony between man and the world which according to Worringer would explain the creation of a naturalistic and "classical" art? Perhaps it should be admitted that only in some few felicitous moments were the Greek people capable of creating the naturalistic art of the Venus of Milo, while right afterwards (or simultaneously) through a dialectic of contrary forces it created such inordinate monsters as The *Bacchantes.* And here, it should be observed — as we see in more detail in the case of the Renaissance — *that abstraction is not the only form in which the unsatisfied and anguished spirit reveals itself but also very frequently through romanticism and expressionism.* That is one of the basic criticisms that may be leveled against Worringer's theory and, particularly, that of his disciple Hulme in his analysis of Renaissance and modern art.

If this were not enough, precisely among the same Greeks who practiced naturalism, *abstraction* arose on a basis of pure reason and geometry, fundamental to all Western rationalism and positive science. How to reconcile

this new and highly transcendental form of abstraction with Worringer's thesis? And as if this were still not enough and more confusion was yet to come, take note that the rationalist abstraction of the Platonists had partly Egyptian roots via Pythagorean thought and its theory of two worlds.

That duality was initiated in the West with them and constitutes one of the facets of our world vision, a mixture of mysticism and rationalism, of ecstasy and geometry which, struggling with the existential spirit, lasted until today and is manifested in certain Platonic expressions of the abstract art of our time.

There are two great periods in Europe according to Hulme: the Middle Ages and the Renaissance. Belief in original sin was held in the former but not the latter; all the rest is born of this enormous difference. The Middle Ages believed in the radical imperfection of man and man's subordination to certain absolute values, beliefs that constitute the core of any civilization, including its economy. Renaissance ideology, on the contrary, considers man to be essentially good and out of that capital thesis there follows the entire world of its creations. The difference between these two modes of looking at reality is manifest in their two antagonistic concepts of art. While Renaissance art is vital and takes pleasure in representing *human and natural forms,* the Byzantine art that preceded it sought

an austerity, a perfection, a rigidness that vital things were unable to offer. And so, man, subordinated to absolute and eternal values, sought in *abstract forms* the expression of his intense religious emotion, the precarious but, none-theless, well-directed attempt from a temporal and chang-ing world to focus on an Immutable and Eternal Universe. *Humanism,* with all its variants of *pantheism, rationalism, and idealism,* represents, according to Hulme, an-thropomorphization of the world. At the beginning, the concept of the essentially good man was manifested in a sometimes heroic form, as in the art of Donatello, Michel-angelo, or Marlowe. Humanism of this kind, in the impla-cable Hulme's judgement, has a certain attraction but does not merit too much admiration because it carried the sentimental and utilitarian germ of romanticism. Sooner or later, that humanism had to come out in a being as abominable as Rousseau. In view of this anthropomorphic, smug, and superficial modality, the abstract art of our time was to come on the scene to reconstitute *a new transcen-dency,* a new religious attitude in search of the absolute.

There is much truth in this formulation of Hulme's, as there generally is in Worringer's. The main defect, in my judgement, is that the dialectical process of history is not considered and, in particular, the contradictory devel-opment of artistic expression.

Hulme seems to have been unaware that the Renaissance was the resultant of a *twofold movement*. On the one hand, of the worldly and earthly spirit of the class that emerged thanks to the development of the communes, which imbued it with a *naturalistic* tendency and, on the other, as a consequence of the same cause, it meant the beginning of a *mechanistic* and *scientific* outlook. While the former led to the concrete, the latter had to inevitably produce an *abstract* universe. And this new abstraction, at least the one that arose from this process, far from signifying the triumph of a religious spirit, meant a weakening to the utmost of the profane spirit.

If Hulme's thesis were correct, the abstract art of our time would be *the search for a new transcendency* and, what is even more debatable, *the only artistic path for attaining it*. Against these two dogmatic assertions it is fitting to propose the following causes of contemporary abstract art.

1. *The humanist and profane Renaissance so disdained by the British essayist.* Beneath the subtle tremors of the flesh, there are in Leonardo's figures — to point out an archetype — the invisible but rigorous skeletons of his triangles and pentagons, and the whole ordered in accordance with the canons of the divine proportion and perspective. He wrote in his Treatise: "Arrange, then, clothed or unclothed figures of men in the way you intend to use

them, placing magnitudes and measurements in perspective so that no detail of your work shall counter the counsel of reason and natural effect. And in another aphorism, he adds: "Perspective, in consequence, must hold first place among all man's discourses and disciplines. In its mastery, luminous line combines with the varieties of demonstration and is gloriously adorned with the *flowers of mathematics and, even more, with those of physics.*"

Piero della Francesca, painter and geometrician, is the direct forerunner of Cézanne who with his pyramids, cubes, and cylinders is the forerunner of the abstractionists through the cubists. It is not casual that the cubists should have resurrected the golden section and were interested in Luca Pacioli. This genealogy unquestionably links the abstract artists of our epoch with humanism, science, and bourgeois dominance of the external world. Nothing of mysticism nor transcendency in this lineage, at least: out and out Renaissance, technical and profane humanism, not of ancient documents and excavations but of cartographers, geometricians, fortifications, engineers, spinning machines, and cannon casting.

And, as a consequence, contrary to what Hulme assumed, the mystical rebellion of modern times was accomplished through the romantic spirits who, from Donatello and Michelangelo to Kierkegaard and

Dostoy evsky incarnated increasingly and tumultuously the uprising of the religious spirit against the technology-worshiping spirit of a bourgeois civilization. We find their last descendants among postimpressionists like Van Gogh and Gauguin, among the *Fauves* and the expressionists, the surrealists and, in short, among those artists who, although having sprung from abstraction, turned toward the production of *concrete objects* invented by *their own egos* and not by virtue of a process of abstraction of the world around them; a typically romantic and autistic attitude no matter how deceptive the asceticism of its geometric forms might be.

2. *The inner dialectic of art itself.* Aesthetic expressions are not always the manifestation (direct or indirect) of the epoch but rather they also obey the intrinsic dynamic of their own evolution: struggle of schools, exhaustion of forms, repetition *ad nauseam* and even the very spirit of contradiction that is so often characteristic of the artist. Thus, not without following the great arc of each period (romantic or gothic, Renaissance or baroque), the creators, always personal and anarchic, make individual deviations to the left or right, above or below the major lines. And in the great arc that constitutes what we might call "the art of our time," we can find trends as contradictory as Cézanne's constructivism and expressionism, the cubists'

rigorous problem, and surrealist disorder. In recent years, particularly in Argentina, that internal dialectic of schools has brought on a growing boom in abstraction which not only does not signify that figurative art will remain buried forever but, on the contrary, that it *must rise again in an early and inevitable revenge* if the thesis I am presenting is correct.

3. *The asceticism of contemporary art vis-à-vis bourgeois sentimentalism.* The bourgeoisie which triggered through science the most powerful process of abstraction humanity has known, did not for that reason leave off being "realistic," that is, myopically stuck to the most superficial and mundane layer of reality. And, in that way, paradoxically, it dug its own spiritual grave by calling up mental forces that went much further in the direction of the Platonic regions of pure form than petty and self-serving tastes could have wanted.

In securing such independence and by that overstepping of the bourgeois frontier, abstract art has ceased to be part of the essence of the social spirit that called it forth and become an art hated and deprecated by the bourgeoisie.

4. *Chaos.* The only one of the four causes indicated that can (and should) be applied to Worringer's central thesis on the essential disagreement between man and the

world at the root of abstract art. The crisis of our time has placed man out in the cold again, metaphysically speaking. The collapse of bourgeois and rationalist civilization confronts him dramatically with a new chaos and, in the midst of the catastrophe, he hangs on to a Geometric Order.

Anguished spirits often have a tendency to seek in the clarity and security of mathematical organization a system of coordinates to hold on to and in which to find the tranquillity denied them by their inner disorder. I have already observed that Platonism could only have been imagined by men too worried by the passions of body and soul. Sartre's Platonism in *Nausea* has no other origin, and, in the same way, it is impossible to explain otherwise how spirits as romantic, dark, and expressionistic as Mondrian, Kandinsky, and Vantongerloo should have shunted off towards abstract art.

This study was published in the Havana literary review
Ciclón *in 1956. The date is of interest because in it*
Sábato *predicted a revival of figurative painting at a time*
when abstract art was at its apogee.
— *Translator's note*

THE NOVEL, RECOVERY
OF PRIMORDIAL UNITY

THE ADVANCEMENT of the rationalization process was at the same time that of man's abstraction and disintegration.

It is to be expected that the artist, whose creations are radically concerned with concrete man, should have rebelled against this dehumanization. It is also understandable that his rebelliousness should have been aimed against the abstract thought that is responsible for the dehumanization. But in his anger, he has often been incapable of understanding that if it was a good thing to reject abstract thinking as a threat to the emotional world and his own life, concrete thought, on the other hand, could not be rejected. Furthermore, he did not understand that in repudiating ideas *in toto* and in relegating them to the universe of philosophy, the artist was contributing precisely to the consolidation of the calamity against which he had risen up: the fission of the world. And that if art is to bring about the salvation of integral man it must claim the right (which it always possessed) to the vast riches of poetic

thought.

Moreover, no great writer has ever attempted such suicide, nor would even be able to attempt it, for he lives in a world not only of sensations but of ethical, gnoseological, and metaphysical values which, in one way or another, impregnate the creator and his work.

Man is neither thing nor animal, not even a man alone. And his problems are not those of a stone or a bird (hunger, material shelter, food). His problems and tribulations arise mainly from his societal condition, from the system in which he lives amidst family situations, social class, striving for wealth or power, resentment over his interdependent situation. How can a novel, even without reaching the ultimate dilemmas of the human condition, be truly serious without formulating and discussing those problems? And what else are those formulations, those discussions, but a complex of ideas, isolated or systematic, incoherent or constituting a philosophy? The drama of *Romeo and Juliet,* as someone observed, is not a simple matter of sex, nor even a question of mere sentiment, since it is brought about by a configuration of a social and political nature. Nor would *The Red and the Black* make any sense without the social context of rancor and ambition in which Julien Sorel moves, and without Rousseau's ideas that underlie Stendhal's narrative, ideas pre-existing

his own fiction that in one way or another inspired or marked his novels which, in any case, gives them their philosophical consistency and human significance. Nor is it possible to conceive the vast Dantesque poem without the Thomist philosophy which ruled his world of ideas and even his world of passions, since the passions also are unleashed or, at least, deformed by the ideas. Nor is it possible to imagine a Proust unaware of Bergson, unsaturated with all the ideas of his time about music and painting, love and death, peace and war. (Cf. Lionel Trilling, *The Liberal Imagination,* on this group of reflections.)

Furthermore, to the degree in which our civilization is becoming more and more problematical, there is scarcely a human being who is not continually concerned with political or social ideas, dominant ideologies such as nazism, which, on top of everything else, have unleashed the most violent passions. And who but the novelist or playwright will be able to and should take cognizance of those passions that are inextricably combined with ideas? And by virtue of what senseless mania should he extract (mortally) the ideas from that mixture and leave only the passions? Having heard that ideas belong to philosophy and science, many writers have sought, nevertheless, to ban them from their fiction, thus practicing a kind of curious unrealism inasmuch as, poorly or well, men never

cease thinking and it is not clear why they should leave off doing so from the moment they are transformed into characters in a novel. To recognize the enormity of such nonsense, suffice it to imagine for a moment what would be left of the work of Proust, Joyce, Tolstoy, Dostoyevsky, Musil if we were to excise the ideas.

The aware writer is an *integral being* who acts in the fullness of his emotional and intellectual power to give testimony of human reality which is also inseparably emotional and intellectual. Then, if science must dispense with the subject to provide a simple description of the object, art cannot dispense with either of the two terms. And although art is specifically emotional, we must not forget that man also feels intellectual emotions. None of the great creators we have been mentioning limited himself to conveying sensory emotion.

They convey a highly complex, dramatic universe to us in which feelings and passions seem to appear joined with elevated spiritual values, ideas, or moral and religious principles, to a philosophical or esthetic construct. This total vision of the universe has been possible thanks to the complex humanity of those creators as well as a long life, not only contemplative but active, not only of reading and meditation but also of life experiences, notions acquired from lives and deaths; all of these reasons why the writing

of a novel calls not only for talent but long and profound experience.

Generally, these creators combine acute hyperesthesia and superior intelligence with the characteristic of being incapable of insulating their thoughts from their feelings — as happens with pure philosophers — whether because of the enormous parallel intensity of their feelings and emotions or because they feel like no one else the *essential unity of the world.* And their characters are never merely effects of their ideas but rather the manifestation or carnal spokespersons of those ideas. And the greater the mental charge the profounder and more transcendent the ideas since existence is more existence the deeper we plumb it through consciousness.

A profound novel cannot be metaphysical since underlying the family, economic, social, and political problems on which man holds discourse there are always the ultimate problems of existence: anxiety, desire for power, perplexity and fear in the face of death, yearning for the absolute and eternity, rebelliousness at the absurdity of existence.

Furthermore, those ultimate dilemmas do not necessarily appear in fiction in the abstract form they assume in philosophical treatises, but through the passions. The problem of Good and Evil is posed through the murder

of the usurer by a poor student. However, a human being does not restrict himself — as the objectivists seem to think — to killing by bringing into action a weapon wielded at the end of an arm, and not even such physical acts are accompanied purely by sensations. Man is also a thinking being and it may well be that his thoughts are not the primitive and stumbling ones of a quasi-idiot criminal but the system of ideas of a criminal who seems to want to demonstrate some twisted and astonishing philosophical doctrine through his act, such as happens in Dostoyevsky's novel, for example. And so it is that in many novels not only are we in touch with a philosophy implicit in the character and general atmosphere, as in Kafka's work, but strictly philosophical discussions may even develop, such as in the dialogue of the Chief Inquisitor.

But there is not even any need for the artist to consciously profess a system of ideas since his immersion in a culture makes of his work a living representation of dominant or rebellious ideas of the contradictory remnants of old bankrupt ideologies or profound religions. Not Hawthorne, nor Melville, nor Faulkner can be explained without the stamp of protestant religion and biblical thought, although they were not believers or militants in the strict sense, and it is precisely that mark on their spirit that gives magnitude and transcendency to their novels

which for this reason surpass the hierarchy of simple narration with their profound and searing dilemmas involving good and evil, fatality and free will that the old religions put forward and which recover their scintillating grandeur through the novelistic creatures of those artists; dilemmas that attain such tragic grandeur because bedeviled as they are, as are all gigantic creators, they bring into the world characters corrupted by Evil, the Devil in those creations taking on all the living and carnal force that is only described in theory and abstraction in theological treatises.

There is an inherent cosmic vision in all great novels, all great tragedies. Thus Camus can assert, rightly, that novelists like Balzac, Sade, Melville, Stendhal, Dostoyevsky, Proust, Malraux, and Kafka are philosophical novelists. There is a *Weltanschauung* in any of those capital creators, although it would be more exact to say a "vision of the world," an intuition of the world and man's existence, since, contrary to the pure thinker who offers us merely a conceptual skeleton of reality in his treatises, the poet gives us a total image, an image that differs as much from that conceptual body as a living being from its brain alone. Nothing, however, is demonstrated in those powerful novels in the way done by scientists or philosophers: a reality is shown. Not any reality, though, but one selected and

stylized by the artist and selected and stylized in accordance with his vision of the world so that his work is in some way a message, *means something,* is a form that the artist has of communicating a truth to us about heaven and hell, the truth that he notes and suffers. He gives us no proof nor demonstrates a thesis, nor does he make propaganda for a party or church. He offers us *a meaning.* Meaning that is almost entirely the opposite of thesis, since the artist brings about something in those novels that is almost diametrically opposed to what propagandists produce in their odious output. Those great novels are not meant to moralize nor edify, they are not aimed at lulling the human creature and tranquilizing it in the bosom of a church or a party. On the contrary, they are poems intended to awaken man, to shake him out of the fleece-lined lair of commonplaces and comforts, that are inspired rather by the Devil than the sacristy or politburo.

This is a time of crisis but also of passing judgement and of synthesis. In considering man's deep rift, art appears as the instrument that will reclaim lost unity. This was generally the attitude of romanticism which vindicated the Faustian vis-à-vis the Apollonian. The members of the Jena circle were not mistaken in seeking to identify opponents, the Schlegels, Novalises, Holderlins, and Schellings who sought to unify philosophy with art and religion, those

men who in the midst of scientific fetichism intuited the necessity of resurrecting primordial unity.

And there is nothing in the activities of the human spirit more indicated for that synthesis than art since all its faculties come together there, an intermediate realm, as it were, between dream and reality, conscious and unconscious, sensibility and intelligence. The artist, with the first plunge into the tenebrous depths of his being, delivers himself over to the powers of magic and dream, traveling back and into the territories that return man to infancy and to the immemorial regions of the race, where the basic instincts of life and death hold sway, where sex and incest, paternity and parricide deploy their ghosts. It is there that the artist finds the great themes of his dramas. Then, in contrast to dream, which anguishingly considers itself compelled to remain in that ambiguous and monstrous terrain, art turns back to the luminous world from which it had separated, impelled now by an expressive force; a moment in which those materials of the darkness are fabricated with all the faculties of the creator, now fully awake and lucid, no longer archaic or magical man but man of today, denizen of a communal universe, reader of books, receptor of prefabricated ideas, an individual with ideological prejudices and social and political position. That is the moment when the parricide Dostoyevsky gives way partially and

ambiguously to the Christian Dostoyevsky, to the thinker who will mix with the nocturnal monsters that emerge from within him the theological or political ideas that torture his head; dialogues and thoughts that, nevertheless, will never have the crystalline purity imparted by theologians and philosophers in their treatises since they come promoted and deformed by those dark powers emanating as they do from the mouths of characters that stem from the irrational regions, whose passions have the fierce and indomitable power of nightmares. Forces that not only push but deform and proffer the ideas expressed by their characters and which, thus, can never be identified with the abstract ideas we read in a treatise on ethics or theology. Because saying in one of those treatises that "man has a right to kill" will never be the same as hearing it from the lips of a fanatical student who has a weapon in his hand and is possessed by hatred and rancor. Because that weapon, that attitude, that maddened countenance, that sick passion, that demoniac gleam in his eyes will forever differentiate the merely theoretical proposition from the terrible concrete manifestation.

THE TENEBROUS UNIVERSE OF FICTION

THE PHILOSOPHICAL DRAMA of a man like Sartre is that in repudiating his own creative fiction, he leans towards the inauthenticity that he denounced all his life and which the protagonist of his most revealing novel very blatantly denounces.

A trend persisted, handed down from the Orphics who saw in earthly life nothing more than sadness and grief: only through purification and renunciation was it possible to escape the corporeal prison and ascend to the stars. Orphic disdain was inherited by Socrates (albeit with dubious motivation) and, from him, through Plato, it was to find its way to Christianity. Among Christian thinkers, Pascal was the one who most pointedly paved the way for Sartre: "Taking God away from him will suffice." Sartre was educated under the influence of the Protestant branch of his family. Once God was eliminated, his concept of Good and Evil brought him to a sort of atheistic Protestantism, to a harsh morality. Without the dark unconscious

that had to fatally explode in his fiction disappearing below his other ego. If, above, he speaks in favor of culture and literacy as becomes a progressive intellectual, below he laughs pitilessly at the autodidact; if, on the honorable ground floor, he defends the communal spirit, in the tenebrous cellar he is a fierce individualist who distrusts communication; then, if above he finally comes out in favor of the earthly paradise of collectivism, below he will grumble that the earth is (will always be, because it isn't a matter of social system but of metaphysical condition) a hell. In many senses, he is one possessed whose demoniac vision is similar to that of Verjovensky in *The Possessed* who, by dialectical irony, is the son of a progressive teacher.

Another dramatic duality is inevitably brought to mind, that manifested by Tolstoy in his last years when, nearly at the same time as his moralizing essay *What Is Art,* he was writing one of his most diabolical tales, *Memoirs of a Madman.* It is precisely in studying this vital contradiction that Chestov gives birth to one of his clairvoyant essays, putting forth the thesis that novelists' truth should not be sought in their autobiographies or essays but in their fictions. A thesis which if largely correct and of (frightful) fertility, commits the injustice of considering the man who fights his demons a beguiler. That struggle, too, is part of truth. Because awareness of moral values,

the desire to overcome the destructive forces of the un-
conscious, the aspiration to share in communal life also
makes up part of man's dialectical condition. It is under-
stood that Chestov is denouncing the hypocritical fury with
which Tolstoy was hurling moralizing swill at artists who
(like himself) were expressing the dishonorable truth of
their lower depths. It would not be understood that the
same reproach might be levied at a man who, like Sartre,
does not act out of hypocrisy but from complex but never
dishonorable motives; it is indeed legitimate, however, to
reproach him for his attempt to repudiate literature in the
name of politics.

THE GREAT ARC OF THE NOVEL

THE RISE OF THE NOVEL in the West has to do with the deep spiritual crisis that unfolded after the Middle Ages. It was religious in that values were clear-cut and solid and then moved on into a profane era in which everything was to be put on trial and anguish and loneliness were to become more and more the attributes of alienated man. If we are to specify when this took place, I believe we can set it in the thirteenth century when the disintegration of the Holy Roman Empire began and when the Papacy, like the Empire, began crumbling in its universality. Between the two cynical and mighty powers in decline the Italian communes launched the new era of profane man, and the entire Old World was to begin collapsing. Soon man was to be ready for the rise of the novel; there was no solid faith, mockery and unbelief had replaced religion, man was again out in the metaphysical cold. And so, that curious genre was to be born that would bring the human condition under scrutiny in a world where God is absent,

does not exist, or is doubted. From Cervantes to Kafka, this was to be the great theme of the novel, and hence a strictly modern and European creation since the conjunction of three great events was called for which had never taken place before anywhere in the world: Christianity, science, and capitalism with its industrial revolution. The *Quixote* is not only the first example but the most typical one, inasmuch as the chivalric values of the Middle Ages are held up to ridicule in it, from which stems not only the sensation of satire but the painful tragicomic feeling, the terribly sad rending that, evidently, its creator felt and which he transmits to his readers through his grotesque mask. Here, precisely, we have the proof that our novel is something more than a simple series of adventures. It is the tragic testimony of an artist for whom the secure values of a sacred community have collapsed. And the entry of a society into a crisis of ideals is like the ending of adolescence for a child; the absolute has broken to pieces and the soul remains facing despair or nihilism. Perhaps for that very reason the end of a civilization is felt more keenly by the young who do not wish to resign themselves ever to the collapse of the absolute and by the artists who are the only ones among adults who resemble adolescents. And so, this collapse of a civilization is attested to by the suffering youths who travel the roads of the West and the

artists who in their works describe, investigate, and bear poetic witness to the chaos. The novel, in this way, could be situated between the beginning of Modern Times and their present decline, running parallel to this growing profanation (how significant this word turns out to be!) of the human creature, to this frightful process of demythification of the world. The Western novel originates, develops, and reaches its peak between these two great crises. And that is why it is useless and a waste of time to study it without reference to this formidable period which, since there is no choice, must be called "Modern Times." Without the Christianity that preceded them, restless and problematical consciousness would not have existed; without the technology that typifies them there would have been neither demythification, cosmic insecurity, alienation, nor urban loneliness. In this manner, Europe injected into the old legendary tale or simple epic adventure that social and metaphysical urgency to produce a literary genre that was to describe infinitely more phantastic territory than that of the countries of legend: man's consciousness. And it will be made to sink further each day that the end of the era draws closer into the dark and enigmatic universe that has so much to do with the reality of dreams.

Jaspers maintains that the great dramatists of ancient times poured tragic awareness into their plays that not only

moved their audiences but transformed them. In that way, they were *educators of their people,* prophets of their *ethos.* But, then — he says — that tragic awareness was transmuted into an esthetic phenomenon and the audience as well as the poet abandoned their deep, primitive seriousness to provide images without blood. It is possible that in writing these words, the great German thinker had in mind a certain kind of convoluted literature that appears in the West, as it did in all periods of intellectual refinement, because how admit that Kafka's work is not as metaphysically weighty as Sophocles's? In man's confrontation of this total crisis of the race, the most complex and profound that he has faced in his entire history, tragic awareness has recaptured the ancient and violent need through the great novelists of our age. And even when it is a matter, superficially, of wars or revolutions, in the final analysis, those catastrophes serve to set the human creature at the frontiers of his condition through torture and death, loneliness or madness. Extremes of man's misery and grandeur which manifest themselves only in great cataclysms, permitting the artists who record them to reveal the ultimate secrets of the human condition.

It is man's body that situates him within the animal kingdom, but he is not body alone; nor is he only spirit, which is rather our divine aspiration. What has to be saved

amidst this hecatomb is the specifically human, the soul, sundered and ambiguous ambiance, site of the perpetual struggle between carnality and purity, between the nocturnal and the luminous. Through pure spirit, through metaphysics and philosophy, man sought to explore the Platonic universe, invulnerable to the powers of Time; and perhaps he may have done it, if Plato is to be believed, through the memory he retains of his primordial confraternity with the gods. But his true homeland is only this intermediate and terrestrial region, this dual and mangled region from whence the phantoms of the novel arise. Men write fiction because they are incarnate, because they are imperfect. A God does not write novels.

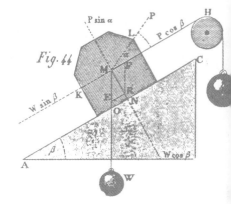

Fig. 44

APPENDIX:
THE UNKNOWN
LEONARDO

THE AMBIGUOUS LEONARDO

FEW WORDS ARE AS DECEPTIVE as the verb "to know" when used in reference to human beings. Acquaintances abound in life but even the most limpid of them is capable of astonishing and even terrifying us with the chasms and monsters of his dreams. What are we to expect of a genius who is infinitely beyond him in his virtues and defects?

Leonardo was handsome, dressed elegantly in velvet, enjoyed conversing at social gatherings — *fun nel parlare eloquentissimo* — fenced superlatively with the foil, a spendthrift, at least in his youth, vain, and enjoyed astounding the court with the spectacles he staged.

This was the ostensible Leonardo.

The other cryptic one was a great unknown and one we must infer from the elusive melancholy of his canvasses, the equivocal, slightly demoniac smiles of his women and saints, the profound contempt emanating from some of the diary notes about men and social reunions. He perhaps felt more than once the same sensation Kirkegaard did

after a party at which he had been especially scintillating:
a suicidal impulse.

When alone, what was his semblance like? We might
suspect that it had something of horror, or even tragedy,
about it. Because we always wear a mask, a different mask
for each role assigned us in life: the honorable parent, the
cautious lover, the strict teacher, the venal scoundrel. But
when, finally, in solitude, we remove the last mask, what
expression do we wear? When nobody, absolutely nobody,
is watching, is making demands on us, is giving orders or
attacking us?

And, then, at the entrance to his studio that he had
while in Ludovico il Moro's service, two panels made us
aware of the triviality of his court-commissioned represen-
tations: a dragon in the one on the left, a flagellation of
Christ on the right. But even after passing inside, on
watching him work, the most intricate duality began to
unfold. As scientist, he drew upon luminous reason; as
artist, he explored a universe that could only be investi-
gated through dark and unfathomable poetic intuition, a
universe already proclaimed by the two symbols at the
entrance, terrain in which his night-blind eyes were capable
of visions that the ordinary mortal encounters only in
dreams. There Leonardo was tormented by Evil and by
his metaphors of the dragon which the hero, in all legends,

must conquer; and by the Medusa with angry snakes for tresses, which evokes meaningful remembrance of Beaudelaire, another tormented one: "What is strange in woman — predestination — is that she is, at the same time, sin and hell."

It is very difficult to really know Leonardo da Vinci but surely we come closer to deciphering him if we consult his ambiguous hieratic symbols.

As a student of physics I was already entranced by this frequenter of salons and morgues, for he seemed to me to embody the sundering of man who passes from darkness into most blinding light, from the nocturnal world of dreams to that of clear ideas, from metaphysics to physics, and inversely. It occurred to me that nobody felt that painful rending as did men (and particularly geniuses) who for good or ill were destined to live at the end of one era and the start of another. With part of his being still in the Middle Ages we recognize in him communication with unearthly forces of some sort, a certain sense of hellish miracles, and an intense concern with Good and Evil; while evident in another part of his personality is the first scientific and technological mind of modern times.

FLESH AND GEOMETRY

A STRANGE ANIMAL, by managing to stand up on its two hind legs, forever abandons zoological happiness to initiate metaphysical unhappiness: senseless yearning for eternity in a miserable body destined for death. Only those ignorant of their end are saved from catastrophe — children. The only immortals.

But everything on the face of the earth suffers time's mercilessness. Even the arrogant pyramids of the pharaohs erected with the blood of thousands of slaves are no more than simulacra of eternity, demolished as they finally were by desert hurricanes and its sands. However, a weightless geometric figure, its mathematical skeleton, is invulnerable to those destructive powers. Under Calabria's clear sky, listening to the harmonies of the most immaterial of the arts, Pythagoras of Crotona was the first to intuit an eternal universe of triangles, pentagons, polyhedrons.

Some hundred years later, a prodigal genius, a man who deeply (and, possibly, dramatically) suffered the pre-

cariousness of his body, dreamed at the same time of a flawless universe and urged his disciples to breach it with geometry. His most famous student sought to explain with a metaphor how mortals won access to that *topos uranos:* In another age, two winged horses were drawing a chariot driven by the soul of man accompanied by gods towards the Palace of Perfect Forms. But at the first glimpse of its resplendence or the Palace itself, perhaps, the human being lost control of the horses and plunged to earth. From then on, he was doomed to see only the crude materializations of those Forms, impelled and battered by the turbulence of this temporal universe. But something was left to it from that confraternity with the gods: intelligence; and geometry, its most perfect achievement, silently indicating to it that beyond the rage of storms, the beings who love and destroy themselves, the empires that rise arrogantly and crumble miserably, lies another universe that is eternal and invulnerable.

And some thousand years later, another genius (who, like all men but with the heightened intensity that genius affords, enjoyed the transitory good fortune of love and friendship and suffered the inevitable wretchedness of time) was also to seek with the aid of mathematics not only power but eternity. And when mathematics did not suffice, through art in which there is no lapse of time. And

he was to say in melancholy moments: "Oh time, consumer of all things, oh, invidious antiquity, which lays waste to all things with the hard teeth of senescence, little by little, in slow death." Why shouldn't he set the perdurable forms of geometry under their fragile images? Consider the *The Virgin of the Rocks:* in the secret basaltic grotto, mysteriously azure and verdigris, delicately remote from the horrible world, beneath subtle raiment and quiet grace of gesture, the austere triangles, the skeleton of eternity.

In the novel *To the Lighthouse,* a woman painter yearns for her painting to be "Beautiful and bright on the surface, feathery and evanescent, . . . a thing you could ruffle with your breath; but beneath the fabric must be clamped together with bolts of iron." This is the esthetic practiced by Virginia Woolf herself and by Leonardo also. An esthetic become metaphysics.

And in that plundering of contingency, that *"necessità"* to which he alludes in his notes: the angel's forefinger enigmatically pointing is no superfluous or purely decorative element. In the variant at the National Gallery made by students or imitators, the gesture was eliminated and the painting is subtly inferior.

THE ARTIST'S INELUCTABLE EGO

RESPECTFUL OF SCIENCE, a contemporary of the great discussions on Platonic ideas, Leonardo did, of course, paint on triangles, circles, and pentagons, but the tremulous flesh of his angels and madonnas was subtly but ineluctably disengaged from the mathematical rigidity, as from those heavy devices which, after his nights in the morgue, he used to imitate hearts and voices. The mystery of life and death which he sought in vain to unveil in his dissections and clumsily to recreate in his robots, was, however, achieved in his painting.

The struggle between the desire for objectivity that characterizes science and the inevitable subjectivity that burgeons in art comes out dramatically in Leonardo. What are those silent grottoes in which his ambiguous semblances take refuge but Leonardo's indirect portrait?

CONCRETE UNIVERSALITY

IRRITATED, PERHAPS, BY SANCTIMONY, Benedetto Croce conceded Leonardo no philosophical status. Clearly, he is correct if we understand "philosopher" to mean one who has elaborated a system of thought. But if one considers the search for the Absolute via the intuition that is at the same time intellectual in the scientist and emotional in the artist, it does not seem to me spurious to consider him the precursor of the archetype imagined by German romanticism for reconciling the rational and the irrational.

Paul Valéry assures us that "Power is what matters to him." To him, he is primarily an engineer who opened the sluices of modern technology. But that primarily is what seems to me inaccurate, since he not only investigated the truths of physics but pursued that Absolute with the fullness of his faculties, intellectual and emotional syllogisms and theorems being uselessly clumsy for recovering the key to myths and dreams. And those bifacial beings differ in this from the strict philosophers Croce was thinking of

when he voiced his harsh opinion. To be sure, to compare him with Hegel would be grotesque, but we could propose him as the *Kraftmensch* favored by German romanticism and as a foreshadowing of Nietzsche's Superman.

Doomed, like all men, to finiteness, Leonardo felt nostalgia, almost yearning, for the Infinite. Is it not the *Sehnsucht* of those poets and thinkers of Germany? Is that leap from the finite to the infinite not the one always made by total artists like him? Was Schelling exaggerating when he maintained that art forms are the forms of the thing in itself?

Furthermore, to assume that the essence of reality can only be grasped by the pure thought of philosophers is arrogance on the part of the rationalist culture that has dominated the West for two thousand years. Why must it be they and not those dual individuals like Leonardo? Even the greatest of those thinkers had to resort to myth when they sought to reach the Absolute.

When man was integral and not this pathetically sundered being that modern mentality has provided us, poetry and thought were a single manifestation of the spirit. As Jaspers asserts, the entire gamut of human expression was impregnated with poetry from the magic of ritual words to the representation of human destiny, from invocations of the gods to prayers. And the first philosophy, that

primordial investigation of the cosmos from the Ionic coasts, was nothing but a profound and beautiful expression of poetic activity.

The blood relationship between poetry and myth was already recognized in the eighteenth century by the Neapolitan, Giambattista Vico, and it is unquestionable that works of art are mythologies that reveal ultimate truths about the human condition, even though in the sybilline manner inherent in them. We do not "know" exactly what Kafka meant by his vast symbol (neither did he) but if we are disturbed it is because of something profoundly true and revealing. That "something" is the mystery of art, irreducible to any class of reasons that are not the Pascalian *"raisons du coeur."* And Pascal was a mathematical genius who at eleven years of age astonished the great specialists: it could not have been out of pique that he established that definitive assessment.

THE DESPAIR OF COUNTLESSNESS

BUT LEONARDO NOT ONLY SOUGHT after the Infinite in depth but in extension, which was perhaps his gravest error because it is unencompassable. This foolishness is patent throughout his five thousand pages of notes. With neurotic anxiety he rushed from dragons to aeroplanes, aortas to annuciations, saints to war tanks. And to top it all, he was possessed by the drive for perfection. "He always sought to attain excellence beyond excellence and perfection beyond perfection," as Vasari says. And, as was to be expected, envy or plain stupidity confirm the fatal flaw that marks his penchant for the infinite. Lorenzo let him leave Florence with no more than a letter of recommendation to Ludovico who listened with the usual scorn of realistic men for projects that could immensely extend reality. To comply with his brother Giuliano, more than anything, Leo X commissioned a painting but when he noticed that Leonardo was beginning to study certain plants for preparing a new varnish, he shrugged his shoul-

ders and commented: "This man is not here for nothing" when he should have said, "This man is not here for nothing that is not eternal." But, let us be fair. He was partly right. That calls for an eternity.

Practically isolated in Rome, he continued his botanical research, discovered the laws of phylotaxia and heliotropism, explained the rise of sap by capillarity, drew maps of the papal coastline, prepared for draining the swamps of the region, discovered the law of the parallelogram, invented the first mechanical die for striking coins, studied falling bodies, conceived the gyroscope, investigated bird anatomy and the physiology of flight, calculated wind power, grappled with the problems of density, and pursued his treatise on voice.

He began to feel old, preoccupied with death, and wrote in his notebook in tiny letters: "One should not wish the impossible."

Then, Francis I invited Leonardo to France and he set out with his instruments and sketches, his models and robots, his manuscripts and colors. He feverishly carried on his investigations there seeking to take advantage of every remaining minute. But there was too much to be done, time now rushed on dizzily, and he felt his work to be intolerably slow. It had taken him ten years to paint the Supper and he was unable even to finish Christ's face.

Perhaps because only God could. He wavered from one side to another, problems multiplying in a labyrinthine manner, and he went from fortifications to physics and from physics to anatomy, and yet, aged and weary, he had to put on court spectacles which he organized with veiled but painful sarcasm; that's what he was being paid for. Then, he returned to his pavillion at Cloux and continued. He took his Mona Lisa and his John the Baptist there for retouching for their expressions did not exactly correspond to what he had intuited over the years. His right hand now dangled inertly and he had to work exclusively with his left. During nights of dark despair he brooded over his scattered oeuvre, his failed projects (such as Sforza's horse), the deterioration of the Supper, and the tremendous mass of manuscripts waiting to be organized: treatises on anatomy, hydraulics, optics, painting, architecture, flight, fortifications.

All was to remain unfinished.

Consider the self-portrait he then drew with sanguine hand. Beneath the powerful forehead, two penetrating eyes scrutinizing the Universe from the depths of an impenetrable spirit; a bitter mouth denoting repressed disgust and virile melancholy. How far from that slim and glowing adolescent Messer Piero had brought to Verrocchio's studio! Consider the work of time and misfortune: what a

chasm, dug by disillusion and bitterness, between that countenance and the one Andrea del Verrocchio did of him in his young David! What a measureless expanse of deserts and wild beasts! Faith and disappointment, love and hate, deaths experienced or anticipated, autumns that saddened or discouraged him, the phantoms that visited him in his dreams were leaving their traces — slowly and inexorably — upon that visage of old age. In those eyes that wept in pain, that shut in sleep and in modesty or shrewdness as well, in those lips pressed together in stubbornness and cruelty too, in those eyebrows drawn together in uneasiness or surprise, that so often lifted in questioning and doubt, the mobile geography was being traced that the soul ends by engraving upon the fine and malleable texture of the face, revealing itself thereby, according to its own fate (since it can exist only incarnate) through the flesh that is, at once, its prison and only possibility of existence.

Yes, that's it: the face with which Leonardo's soul observed (and suffered) the Universe. Like a condemned man behind bars awaiting execution.

OH, IMMORTAL DEATH!

AFTER THE LAVISH CELEBRATIONS organized by his monarch in honor of the Dauphin and Lorenzo, he shut himself up in his pavilion and made note: "I will now go on." But the severe winter of 1519 and fate had decreed otherwise. When Leonardo realized that his time had come, his spirit returned to a little village on the slopes of Monte Albano, undoubtedly saw an old olive tree in whose shade he dozed the solitary siestas of summer, saw a grotto that he explored with fear and fascination, and heard the murmur of the brook. For, as we come closer to death, we also come closer to earth; not the earth in general but that miniscule (but so beloved, so yearned for) spot where childhood was spent, where we played our games and initiated our magic. And then we remember a tree, the face of a friend, a dog that romped with us, a dusty and secret path in the summer siesta, a whirring of cicadas, that little brook. Such things. Not grand things, but the most modest things, which at those moments take on

melancholy majesty.

He called his friend Messer Francesco di Melzi, entrusted him with his manuscripts, charged him with his last dispositions, and in his final moments, declared that he had forgiven the injustices and bitternesses of an implacable world. And, on May 2, 1519, he died far from his homeland, commending his soul to the God he had admired as the supreme and true Creator.

His remains were lost during the wars that scourged that part of the world, as they did before and always, as they scourged and will scourge others. A French poet of the romantic period, Arsene Houssaye, searched for his skeleton in the most likely places and, finally, selected one that corresponded to a tall body with a large head. He buried it at the Saint-Blaise chapel and placed a small headstone over the grave. Perhaps the remains still rest there which Friedrich Nietzsche said were keeping the silence of one who had seen a vast region of Good and Evil. A few bones, or the powder of a few bones, all that is left of the body of that teeming genius.

THE AUTHOR

ERNESTO SÁBATO, Argentine essayist and novelist, began his writing career in the 1940s, while Professor of Theoretical Physics at La Plata University. His first book, *Uno y el universo,* published in 1945, was a brilliant literary and philosophical work, which was followed by two other books propounding the problems of modern man, *Hombres y engranajes* (1951) and *Heterodoxia* (1953). Sábato's international reputation as a novelist rests on three important books, *El túnel, Sobre héroes y tumbas,* and *Abaddon el exterminador.* He has won numerous awards, most recently the 1989 Jerusalem Prize for "the most significant contribution to the ideas of the freedom of the individual in society."

THE TRANSLATOR

ASA ZATZ has translated all three Latin-American titles in the Fiction & series. His other recent translations are *The Dead Girls* and *Two Crimes* by Jorge Ibargüengoitia, *Clandestine in Chile* by Gabriel García Márquez, *The Perón Novel* by Tomás Eloy Martínez, *The Barbarous Comedies* by Ramón Valle-Inclán, and *Black Novel with Argentines* by Luisa Valenzuela. He has received many awards for his translations. A longtime resident of Mexico where he began his career, Zatz now lives in New York City.